INDUSTRIES OF EAST SHROPSHIRE
THROUGH TIME
Neil Clarke

Acknowledgements

I would like to thank the following for their help in providing photographs, information or advice in the production of this book: Apley Estate; Breedon Aggregates; Ivor Brown; Caughley Society; Diana Clarke; Jim Cooper; Steve Dewhirst; Bill and Heather Duckett; George Evans; Ray Farlow; John Freeman; Allan Frost; GKN Sankey; Lady Harriet Hamilton; Alan Lees; John Marcham; Ron Miles; Toby Neal; Malcolm Peel; John Powell; Shropshire Archives; *Shropshire Star*; Barrie Trinder; and Wikipedia Commons (John Chorley and Roger Kidd). My particular thanks go to Joanne Smith and the photographic collection of the Ironbridge Gorge Museum Trust (IGMT).

Every attempt has been made to trace copyright where appropriate, and apologies are extended to anyone who may have inadvertently been omitted from these acknowledgements.

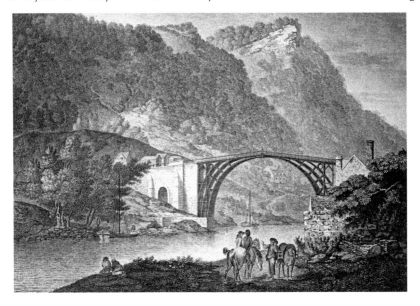

The Iron Bridge – a symbol of the area's industrial heritage. (IGMT)

First published 2018

Amberley Publishing
The Hill, Stroud, Gloucestershire, GL5 4EP
www.amberley-books.com

Copyright © Neil Clarke, 2018

The right of Neil Clarke to be identified as the Author of this work has been asserted in accordance with the Copyrights, Designs and Patents Act 1988.

ISBN 978 1 4456 7023 2 (print)
ISBN 978 1 4456 7024 9 (ebook)

All rights reserved. No part of this book may be reprinted or reproduced or utilised in any form or by any electronic, mechanical or other means, now known or hereafter invented, including photocopying and recording, or in any information storage or retrieval system, without the permission in writing from the Publishers.

British Library Cataloguing in Publication Data.
A catalogue record for this book is available from the British Library.

Origination by Amberley Publishing.
Printed in Great Britain.

Contents

	Introduction	4
PART I:	The Area's Natural Resources	6
PART II:	Manufacturing Industries	30
PART III:	Industry Today	86

Introduction

When the new town established in East Shropshire acquired the name Telford in 1968, sign boards set up on major roads entering the designated area announced 'Telford – Birthplace of Industry' *(below)*. This reflected an earlier epithet applied to one of the historic areas within the New Town's boundary – 'Coalbrookdale: Cradle of the Industrial Revolution.' No doubt other areas in the country could claim a part in the origins of this seminal movement, but East Shropshire certainly played a major role in the development of the coal, iron and clay industries in the eighteenth and early nineteenth centuries. Today, the Ironbridge Gorge Museum Trust (IGMT), with its ten different sites, encapsulates this story.

In addition to the mineral wealth that fostered these industries, the wider area had other natural resources – rich farming land, woodland and water supplies – that were exploited and have in turn produced another range of manufacturing activities.

The extractive and heavy manufacturing industries of the East Shropshire (Coalbrookdale) Coalfield declined in the late nineteenth and early twentieth centuries, only to be briefly revived during the two world wars. However, the advent of the New Town in the 1960s saw an economic revival with the setting up of industrial estates and business parks, which attracted a multitude of new light engineering, technical, food and service industries, and which also tapped into the area's tradition of enterprise, utilising its existing workforce.

This book surveys the range of industrial activity in East Shropshire from previous centuries to the present, and complements the author's earlier books on the transport history of the Coalfield and its surrounding market towns of Wellington, Newport, Shifnal, Bridgnorth and Much Wenlock.

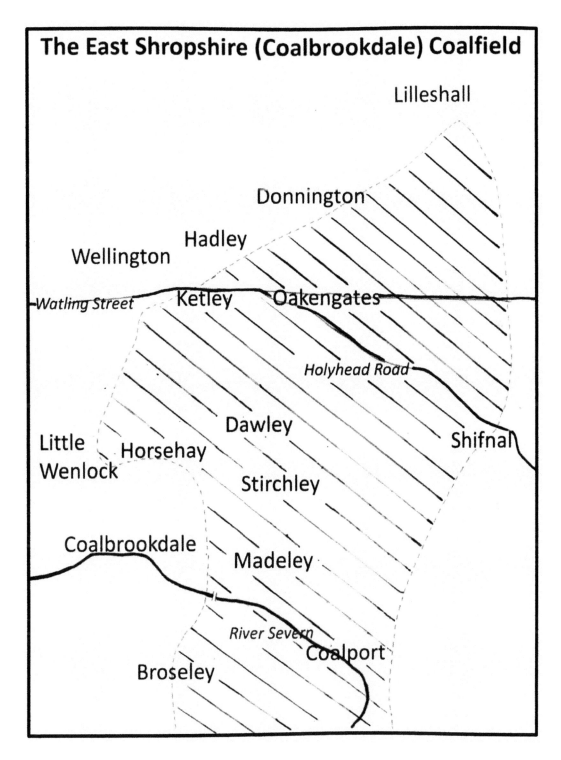

A map showing the approximate extent of the coalfield (shaded), which is some twelve miles from north to south.

Part I: The Area's Natural Resources

East Shropshire has been endowed with a variety of natural resources, both below and above ground. In addition to minerals such as coal, iron ore, clay, limestone and building stone, the area possesses rich agricultural land, woodland and water supplies. A wide range of manufacturing industries developed from these resources.

Mineral Wealth

The East Shropshire (Coalbrookdale) Coalfield extends some twelve miles from Lilleshall in the north to Linley in the south, and some six miles from Shifnal in the east to Little Wenlock in the west. Twenty-one seams of coal in the Lower and Middle Coal Measures have been worked in the past, together with several seams of iron ore, fire clay and brick clay. Carboniferous limestone occurs at Lilleshall and around Little Wenlock, while Wenlock Silurian limestone forms Lincoln Hill and Benthall Edge on either side of the Severn Gorge. Quarries supplying material for building and road-stone have been worked near the Wrekin and at Doseley. Sand, natural bitumen and brine were also found at sites in the Coalfield and beyond.

Surface Resources

The rich soils of the area around the Coalfield have supported both arable and pastoral farming for centuries. The Domesday Survey of 1086 gives a remarkable picture of early medieval land use and, in the following centuries, the wealth of local monasteries was founded on their extensive rural estates. Woodland covered much of the area in the past, as the names of settlements containing the suffix '-ley' (from the Anglo-Saxon: 'a clearing in the forest') testify. The River Severn, cutting through the middle of the area, was not only the principal outlet for the products of the area's mineral wealth but also, together with its tributary streams, provided a supply of water to generate power. These surface-based resources were exploited and in turn produced another range of manufacturing industries.

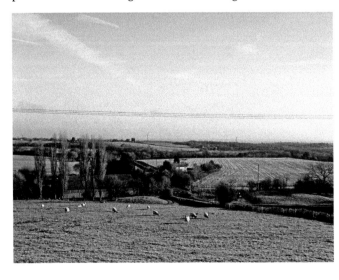

Modern farming in a former mining landscape: Little Worth with Coalmoor beyond, in the parish of Little Wenlock.

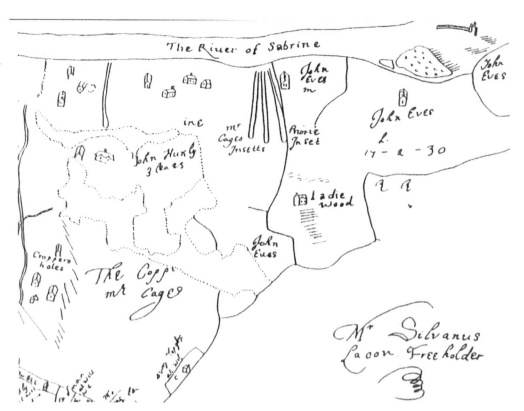

Coal Mining

The Romans may well have been the first to obtain local coal for industrial use, but the earliest recorded mining activity was in the Middle Ages in the Ironbridge Gorge area. Here, early methods of mining included cropping and insetting. Cropping (later called opencasting) involved removing the overburden and exposing the seam of coal that lay at a shallow depth. Insetts, also known as footrids and adits, were tunnels driven into the outcrop of a seam or into the bank until a seam was reached. 'Croppers holes' and 'insetts' are shown on an early seventeenth-century map of Broseley, pictured above. A reconstructed adit at Blists Hill Museum (IGMT) in 1971 is pictured below.

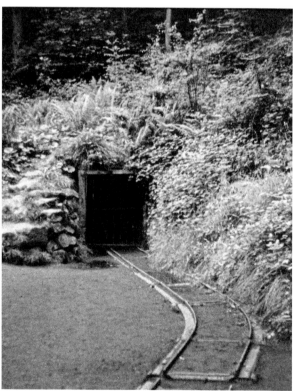

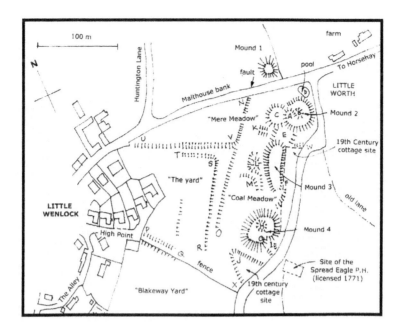

Bell Pits and Horse Gins

Above: When cropping became difficult, shallow shafts were sunk and coal was extracted from around the bottom. Because the excavation was shaped like a bell, these were known as 'bell pits'. The remains of early eighteenth-century bell pits, with the tell-tale feature of a small depression surrounded by a circular mound of spoil, can be seen to the east of Little Wenlock village (*see page 6*).

Below: As seams of coal near the surface were worked out, mines got deeper and extraction by using simple winches was replaced by winding gear operated by horses, known as horse gins. This late eighteenth-century print shows a horse gin operating at a coal pit near Broseley. (IGMT)

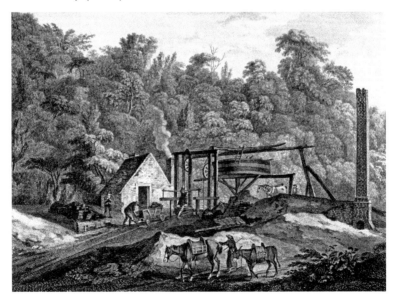

Steam Power

As the coal seams in the southern part of the Coalfield were worked out, it was necessary to sink deeper shafts to access the seams of coal that dipped northwards – a process that was made additionally more complicated by geological faults and drainage problems. Deeper mining was made possible by the application of steam engines for pumping water out of mines and operating the winding mechanism. The above photograph is of the Lloyds Pumping Engine (Madeley Wood) in around 1900, while below is the steam winding engine at Shawfield Mine, Madeley, in 1917. (IGMT)

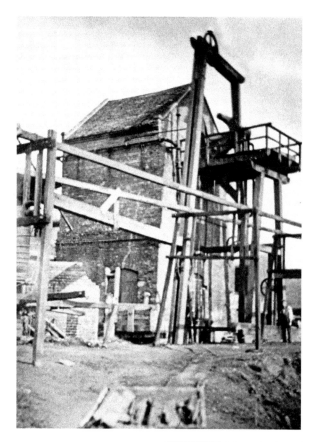

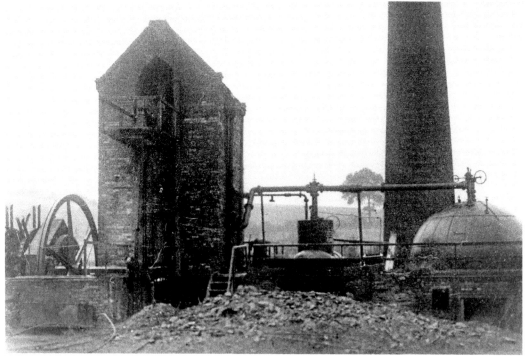

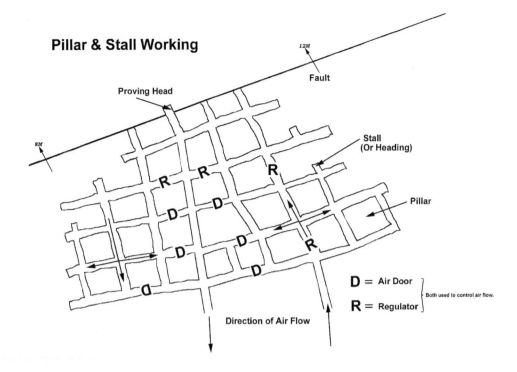

Cycle of Operations

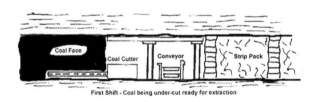
First Shift - Coal being under-cut ready for extraction

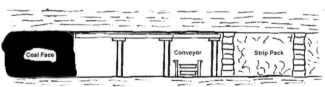
Second Shift - Face lenght of coal has been removed ready to advance conveyor and packs

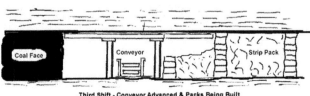
Third Shift - Conveyor Advanced & Packs Being Built

The Coal Face

The traditional method of winning the coal was known as 'pillar and stall', where workings were opened out by tunnelling in a checkerboard fashion, leaving pillars of coal to support the roof (above). Another method, said to have been developed in Shropshire, became known as the 'longwall' system (below): a continuous face of coal was worked using temporary timber or metal props, and the waste area left behind was filled with packs of fallen stone. Coal-getting by machine was developed from 1870. (Drawings by Malcolm Peel)

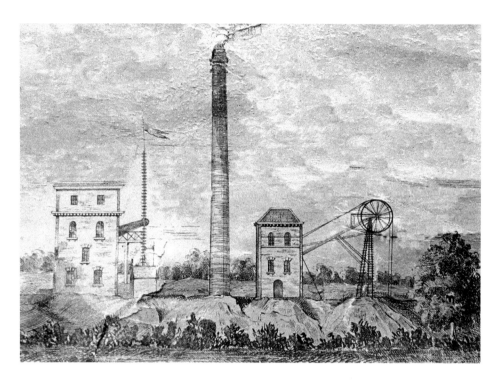

Collieries

By the middle of the nineteenth century, there were some fifty or so collieries (groups of pits or mines) owned by the major ironmaking companies on the Coalfield, which supplied fuel for their furnaces and brickworks. At the end of the century, the two largest companies were the Lilleshall Company in the north of the Coalfield and the Madeley Wood Company in the south. Drawings made in 1864 show (above) the Lilleshall Co.'s Granville Mine and (below) the Madeley Wood Co.'s Kemberton Mine. (IGMT)

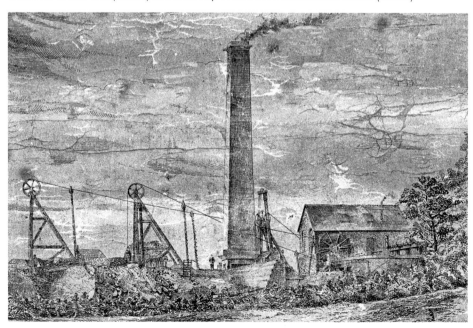

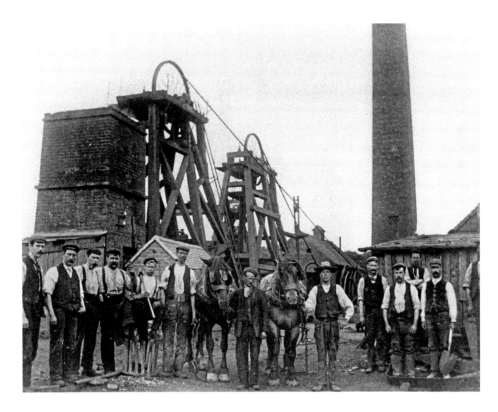

Kemberton Mine

Opened in 1864, and at a depth of 364 yards, this mine was the last deep mine sunk by the Madeley Wood Company. The above photograph shows a line-up of mine workers and horses in front of the two shafts in about 1900. The nearby Halesfield Mine, dating from 1840, was linked underground to Kemberton Mine in 1939, after which its shafts (shown below in 1946) were used only for pumping, upcast circulation and as an emergency exit for both mines. (IGMT)

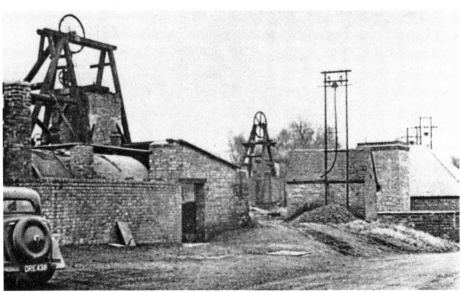

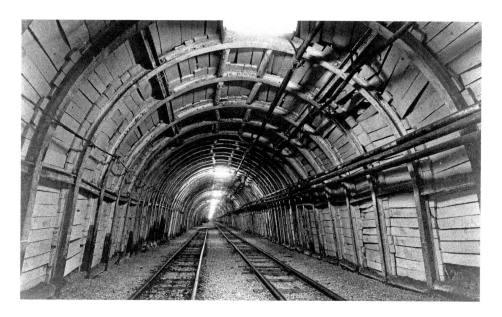

Kemberton Mine

Above: This is the main underground roadway in the years following the nationalisation of the coal industry in 1947. In the 1950s, exploratory drilling near to Shifnal revealed geological faulting likely to hinder the necessary extension of mining activities, and so sealed Kemberton's fate. (IGMT)

Below: The mine closed in July 1967 and some of the miners, shown on the last day of operation, transferred to Granville – the only deep mine left on the Coalfield. All that remains of the Kemberton Mine site, now part of the Halesfield industrial estate, is the pit baths building. (IGMT)

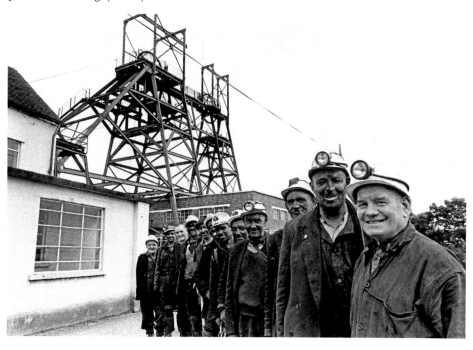

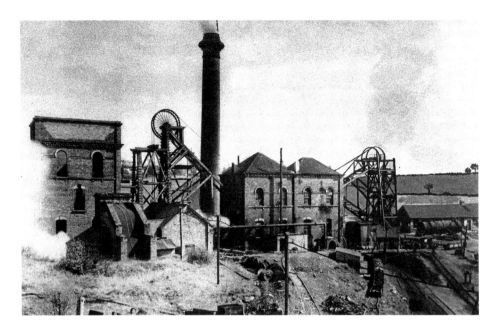

Granville Mine
Of the ten or so former mines of the Lilleshall Company, only two were still operating at the time of nationalisation in 1947 – Granville and Grange.

Above: Granville mine in 1944. (IGMT)

Below: Following its closure in 1952, Grange Mine was linked by tunnel to Granville and became the upcast for circulation. Its post-nationalisation headgear has survived, and the site is now a naturists' centre.

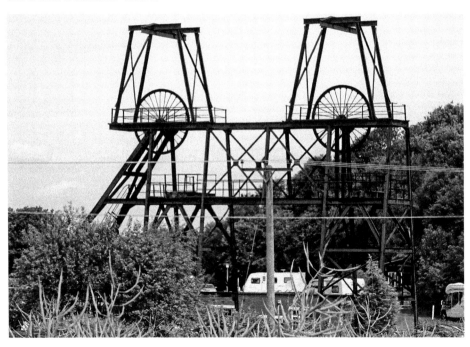

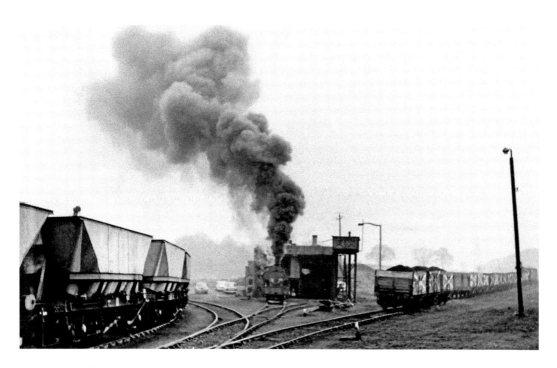

Granville Mine
Above: Coal from Granville (the mine is in the distance on the right) on its way by rail in 1967 to landsale wharves at Lodge Bank and Donnington and to Ironbridge Power Station.

Below: Granville (shown here in 1971) was the last deep mine to close on the Coalbrookdale Coalfield. Following its closure in May 1979, some of the redundant miners transferred to pits in the Cannock area, Staffordshire.

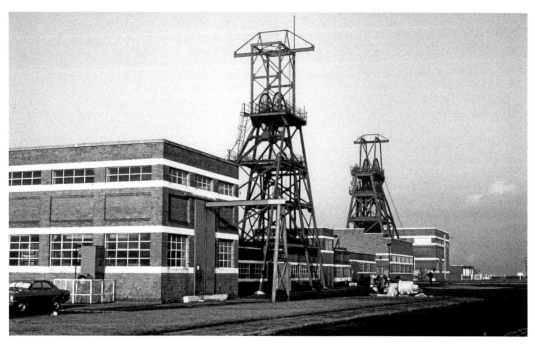

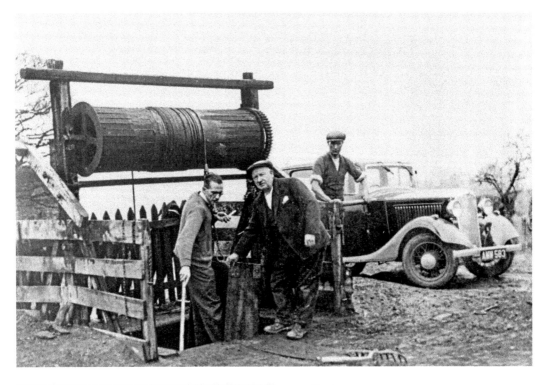

Small Mines

Above: A number of small mines continued to operate in the first half of the twentieth century, of relatively shallow depth and using simple equipment such as hand or electric winches. The Harris family owned mines at Clare's Lane and Old Park, Dawley, the last of which, shown here, closed around 1950. (IGMT)

Left: The Tarr family owned mines at New Works and Coalmoor in Little Wenlock parish. Their adit mine at Shortwood, at the southern edge of Wellington parish, was the last small mine in this area, closing in 1970.

Opencast Working

Right: To retrieve deposits of coal left from earlier mining, various sites in the Coalfield were worked by opencast (surface) mining during and after the Second World War. In Little Wenlock parish this began in 1943, and the opencast site here at Swan Farm was operating in the 1950s. As late as 2010–13, UK Coal worked a controversial opencast site at Huntington Lane.

Below: As parts of Telford were developed in the 1970s, some opencast mining was undertaken prior to new building and road construction. In the older southern part of the Coalfield, opencast mining in the Broseley area at Caughley and here at Posenhall continued until some twenty years ago.

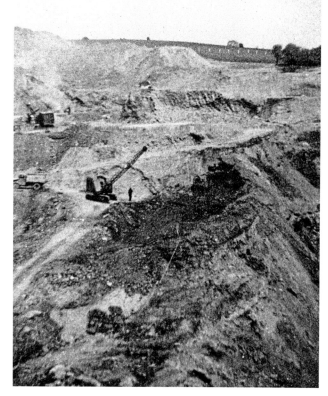

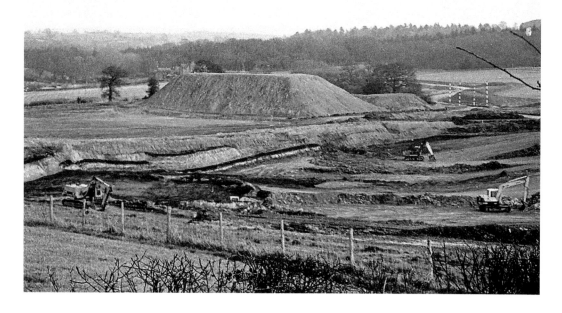

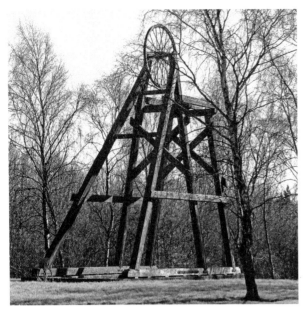

Mining Heritage

There are reminders of the area's mining history in today's landscape. Wooded former pit mounds can still be seen in various locations. The headgear of Harris's Old Park Mine has been re-erected on the Miners' Walk at Blists Hill Museum and the Grange Mine headgear is still in situ. A replica wooden headgear has been erected on Castlefields Roundabout, Aqueduct (left), and iron sculptures of mining scenes originally on display at Ironbridge Power Station have now been moved to Broseley (below).

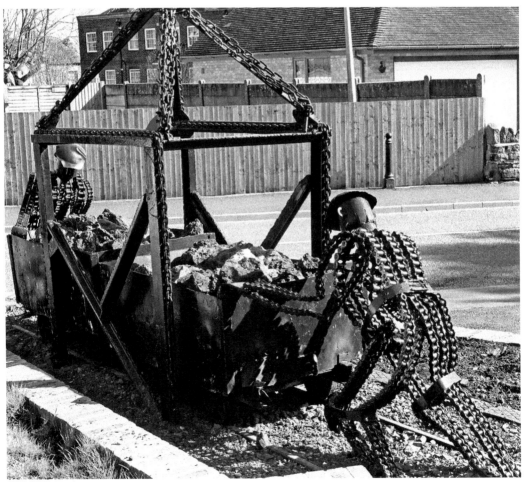

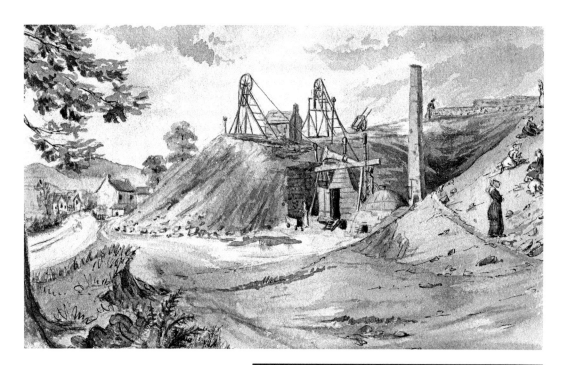

Ironstone

Workings for ironstone were recorded as early as the thirteenth and fourteenth centuries. Demand increased during the Industrial Revolution, and at peak output in the 1870s the Coalbrookdale Coalfield produced over a million tons of coal per year and nearly half a million tons of ironstone. Several of the local mines yielded both coal and ironstone but by the end of the nineteenth century, with ironworks closing, there were only twelve mines producing ironstone.

Above: The painting of an ironstone mine at Madeley Wood in 1847 shows women and girls picking out the ironstone nodules and placing them in heaps prior to firing to remove impurities. (IGMT)

Right: Annie Payne of Dawley, who lived to the grand old age of 104, began working on the pit bank at the Madeley Wood Company's Kemberton colliery in 1900 when she was thirteen. (IGMT)

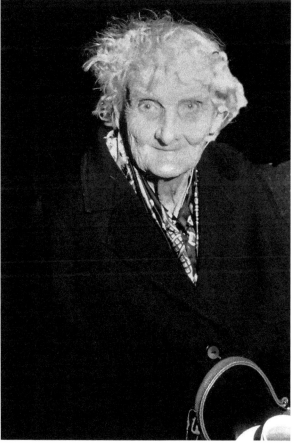

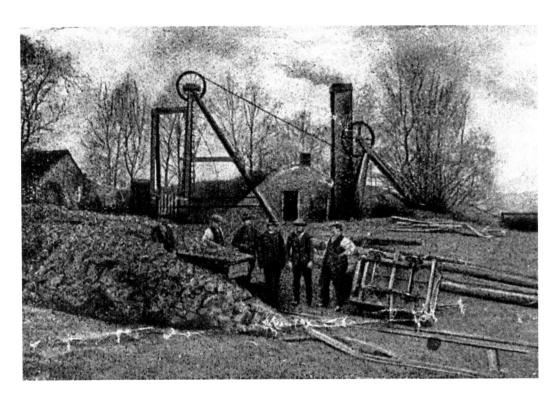

Clay

In the Ironbridge Gorge at Jackfield, local clays were used for making pottery from at least 1560, and bricks from the early seventeenth century. The two main types of clay found in this area are red clay – used mainly for the manufacture of bricks and tiles – and white clay, which is suitable for bricks, tiles, pottery and refractory ware. Originally worked from outcrops and adits, clay was later obtained from mines and, in the twentieth century, from opencast sites.

Above: The headgear of the clay pit supplying Milburgh Tileries, Jackfield, which closed in 1938, was later moved to Blists Hill Museum.

Below: The clay colliery opencast site at Coalmoor in 1982.

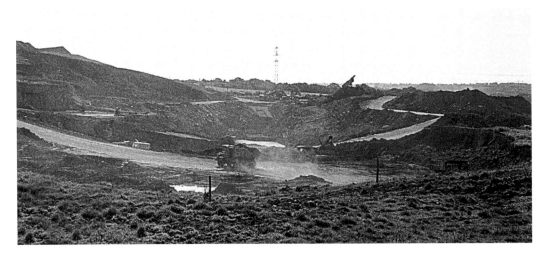

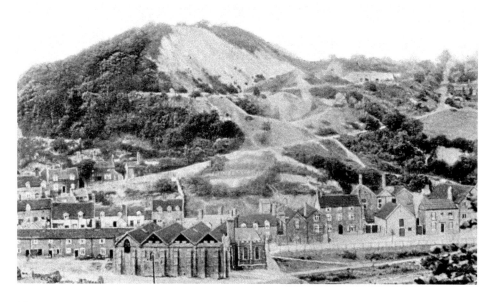

Limestone

The Silurian and Carboniferous limestone strata of the Coalbrookdale Coalfield have been quarried and mined for centuries. There is a record of lime-burning at Steeraway, near Lawley, as early as 1255. Limestone is used as building stone, as a flux in smelting iron and as lime for agricultural dressing.

Above: A view of the abandoned Lincoln Hill (Coalbrookdale) workings, probably the result of a collapse following centuries of quarrying and adit and shaft mining of the Silurian limestone.

Below: The entrance to a Carboniferous limestone mine at Lilleshall.

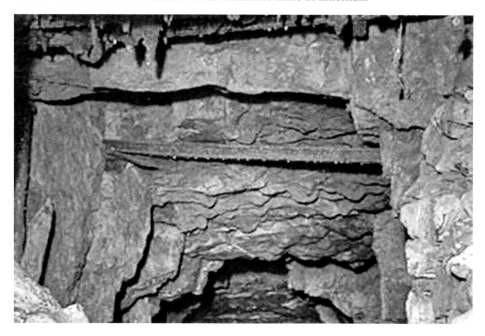

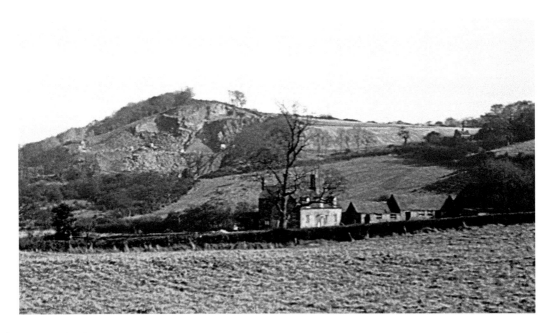

Igneous Rocks

Areas to the east of the Wrekin, around the Ercall, Little Wenlock, Horsehay and Doseley, have been quarried over a number of years for a range of volcanic rocks, including quartzite, dolerite and basalt, which are used mainly as hardcore in roadway construction. One such site, Maddock's Hill, south of the Ercall, was worked for camptonite; it is shown above in 1973, when the hill still retained its shape, and below in 1985, when much of the stone had been removed.

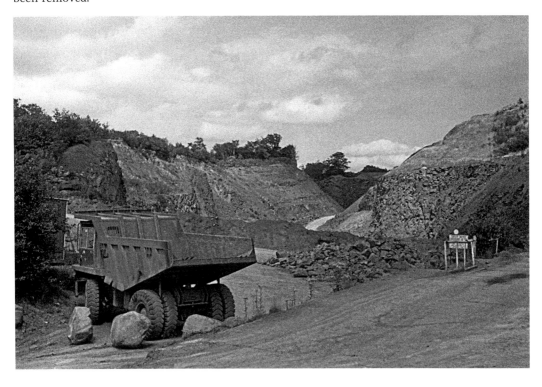

Sandstone

Sandstone has been quarried for building purposes over many centuries: Carboniferous and New Red Sandstone in the Coalfield area and Old Red Sandstone in the Severn Valley around Bridgnorth.

Above: An outcrop of Lydbrook (Carboniferous) sandstone at Jiggers Bank, Coalbrookdale.

Below: A former sandstone quarry south-east of Bridgnorth at Tuckhill.

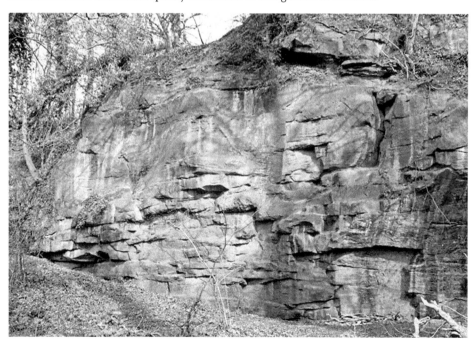

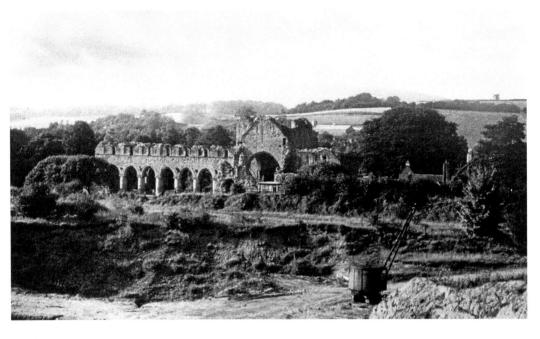

Sand

Beds of sand and gravel, formed by diluvium or drift, are found in several areas within the Coalfield.

Above: Sand workings near Buildwas Abbey, photographed in 1971, have continued to the present day.

Below: The 'Sandhole' at the top of Strethill Road, Coalbrookdale, was worked until the 1950s.

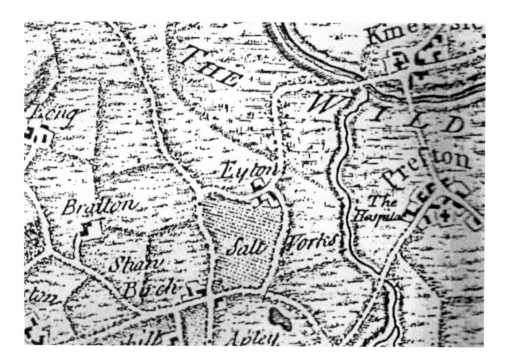

Brine and Mineral Springs

Brine from springs or pits, which was used for the production of salt, was worked in at least three locations in East Shropshire: Donnington, in the Middle Ages, near Preston upon the Weald Moors and at Jackfield in the eighteenth century.

Above: The Kingley Wyche and Charity saltworks on the Weald Moors are indicated on the Rocque map of 1752.

Below: The mineral springs at Admaston Spa, near Wellington, were acclaimed for their medicinal value.

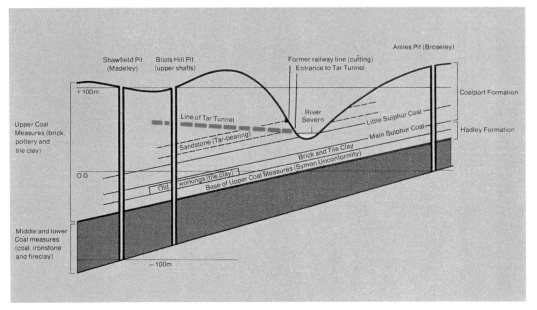

Natural Bitumen

The presence of natural bitumen that could be exploited was an unusual feature of the Coalbrookdale Coalfield. Springs and seepages occurred in a number of places, but the most notable location became known as the Tar Tunnel at Coalport. A tunnel driven into the side of the Severn Gorge (above) that was intended as an underground canal to serve coal mines at Blists Hill struck a spring of natural bitumen in 1786 (left), the exploitation of which became a commercially viable enterprise. (IGMT)

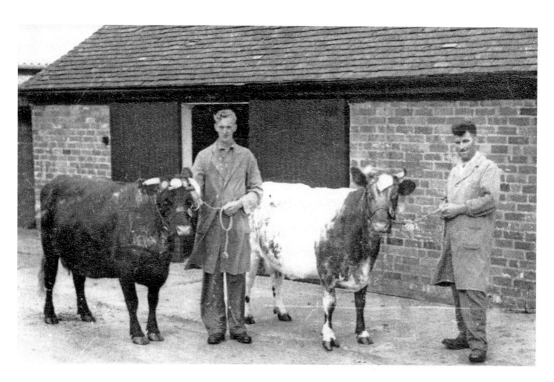

Arable Land and Grassland

The productive soils of East Shropshire have supported mixed farming for centuries. The map published by the Land Utilisation Survey of Britain in the 1930s shows a patchwork of arable land, meadowland and permanent grass, forest and woodland, heath and moorland, gardens and land agriculturally unproductive – and it's the first two categories that predominate locally. These are images of farming on the Apley Estate, north of Bridgnorth, in the early twentieth century – dairy cattle (above) and ploughing (below).

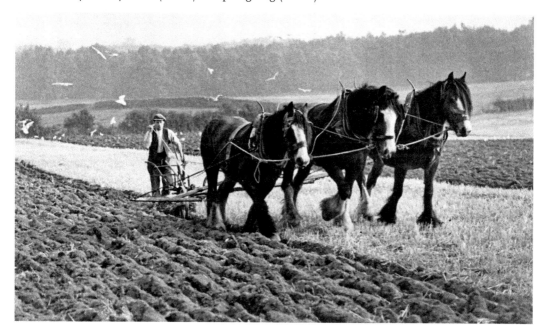

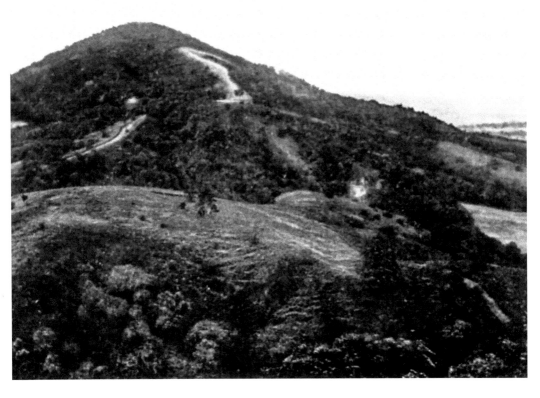

Woodland
Above: The remains of the extensive woodland that once covered much of the area can now only be found surrounding the Wrekin and the Ercall hills, and in the valley of the Severn below the Ironbridge Gorge.

Below: Some timber from the Wrekin is processed at the sawmill of the Raby Estate at Uppington.

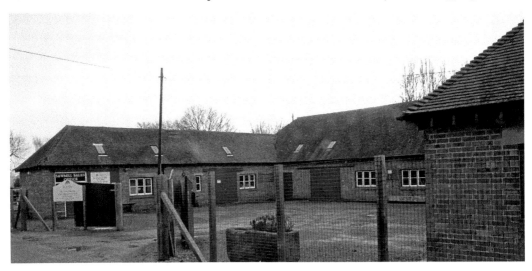

Water Supplies

The River Severn and its tributaries provided water, not only for basic human needs, but also for industrial purposes. Streams, dammed to provide a head of water, drove water wheels that turned the grinding stones in corn mills and (as at Horsehay, above) the bellows of blast furnaces. In the twentieth century, water extracted from the River Severn (below) was an essential element in the generation of electricity at Ironbridge Power Station.

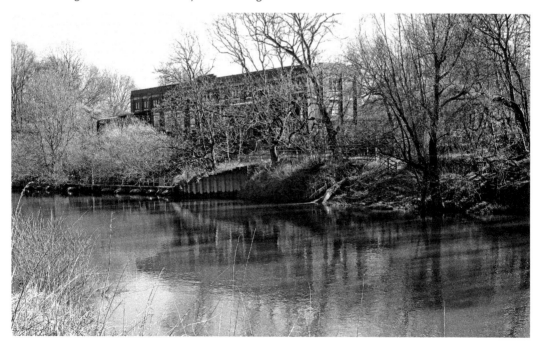

Part II: Manufacturing Industries

A remarkable range of industrial activity has taken place in East Shropshire over many centuries. Artefacts from the Bronze and Iron Ages (possibly made locally) have been found in the area, and it is thought that the Romans used coal in their manufacture of metal and clay products at locations in and around Wroxeter. In the Middle Ages, the local monasteries at Buildwas, Lilleshall, Wenlock and Wombridge granted licences for the mining and quarrying of coal, ironstone and building stone on their estates. The towns that grew up in the area from the medieval period onwards – Wellington, Newport, Shifnal, Bridgnorth and Much Wenlock – developed the manufacture and trade of such items as textiles, leather and metal goods. The granting of market charters and other privileges to these towns recognised their growing status.

However, from the late sixteenth century, the biggest changes in the area developed on the Coalbrookdale Coalfield. Here, the working of deposits of coal, ironstone and clay laid the foundations of the industries that were to give the area an early lead in the Industrial Revolution in the eighteenth century.

At first, most of the coal that was mined on either side of the Ironbridge Gorge was transported down-river to areas where it was used as a domestic and industrial fuel. The coal trade on the Severn continued to expand over the next 250 years, but much of the increased output of the Coalfield was needed to feed the area's developing iron industry in the form of coke. It was Abraham Darby I who first successfully used coke to smelt iron at Coalbrookdale soon after 1709, and from the middle of the eighteenth century all new blast furnaces were coke-fuelled. The earliest method of making coke was to burn off the coal's impurities in open heaps, but coking ovens were later introduced. In the 1780s, Archibald Cochrane (9th Earl of Dundonald) established works at Calcutts (Jackfield) and Benthall for the extraction of by-products from coal – coke, tar, pitch and oil. Several local ironmasters built coke and tar kilns based on those of the Earl of Dundonald. Another by-product of this destructive distillation of coal was what became known as town gas, which was made at a number of gasworks in the area in the nineteenth and early twentieth centuries.

The earliest way of making iron was by the direct process of heating ore in a bloomery; however, by the sixteenth century charcoal-fired blast furnaces producing pig iron had been set up at four locations in the area. The introduction of coke as a fuel in the early eighteenth century, with the availability of local supplies of limestone as a flux, led to a rapid expansion of the iron industry, and by 1800 there were some fifteen ironworks with coke-fired furnaces on the Coalbrookdale Coalfield – one of the country's leading ironmaking areas. At the beginning of the nineteenth century, Old Park ironworks was the largest in Shropshire and the second largest in Britain. During the century, local production of pig iron continued to increase, but its proportion of the national output fell from over a quarter of the total in 1800 to about 10 per cent in 1830 and 4 per cent in 1860. By this time, apart from John Onions' foundry at Broseley, all the East Shropshire ironworks – including furnaces, foundries, forges and rolling mills – were north of the Ironbridge Gorge. Dwindling mineral resources and competition from other areas led to the closure of most of the furnaces by the end of the

nineteenth century, with only Madeley Court, Blists Hill and Priorslee, together with some local foundries, surviving into the next century. Heavy engineering and steel-making firms established in the second half of the nineteenth century at New Yard (Wrockwardine Wood) Horsehay, Donnington and Hadley continued to operate until the 1980s.

Local clays were used in the manufacture of a variety of products from the seventeenth to the twentieth century. There was a concentration of works on the south bank of the River Severn: at Jackfield earthenware and pottery, bricks and tiles, and encaustic tiles were made; Broseley was famous not only for its tobacco smoking pipes but also its bricks and tiles; fine porcelain was made at Caughley and pottery and later drainage pipes at Benthall. North of the river, fine china was made at Coalport; brickworks were built over a wide area, particularly by most of the ironworks owners; drainage pipes were made at Doseley; and sanitary ware was manufactured by the Lilleshall Company at Snedshill (Oakengates).

The quarries of Wenlock Edge were the last productive source of limestone in the area. In the second half of the twentieth century, the bulk of the limestone was used for aggregates in the construction industry, while some was used for concrete-based products and agricultural lime, and a small amount was used for fluxing purposes and building stone.

The produce of the land has fostered a range of manufacturing industries. In the past, crop farming provided barley for brewing and hemp for rope-making, while animal farming provided milk for dairy products, skins for leather, wool for textiles and meat for the food industry. Local woodland at one time provided domestic and industrial fuel, as well as timber for building construction, furniture-making and the production of wood naphtha. Streams drove the water wheels of local corn and paper mills, and a supply of water from the River Severn was a critical factor in the siting of both Ironbridge power stations.

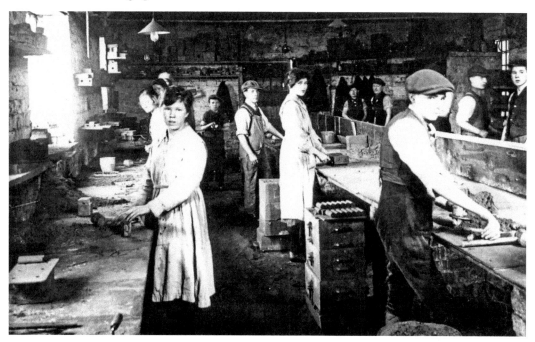

The moulding shop at the Court Works, Madeley, in the 1920s.

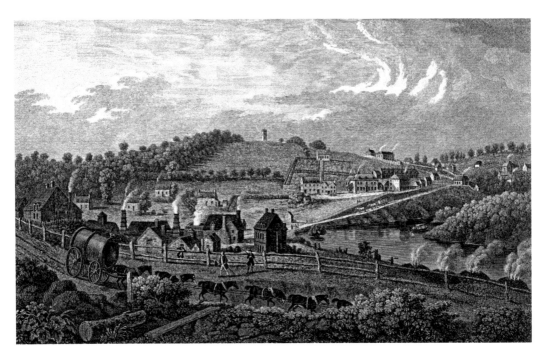

Coke

Above: The earliest method of making coke is depicted in this engraving of Coalbrookdale in 1758, which shows impurities being burnt off four open-air heaps of coal. (IGMT)

Below: Coke was also a by-product of the Earl of Dundonald's 'coal stew ovens', but open-air production was still carried on at most East Shropshire ironworks in the nineteenth century. This is shown at Blists Hill in around 1890, where coal is being coked by stacking around small pillars, then covering and partially firing. (IGMT)

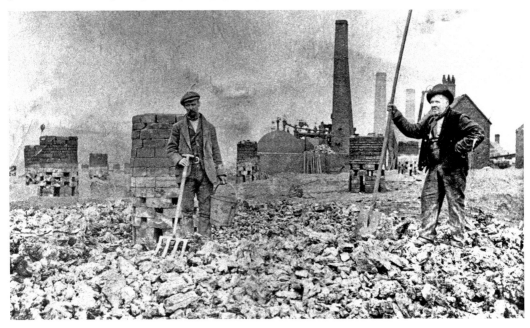

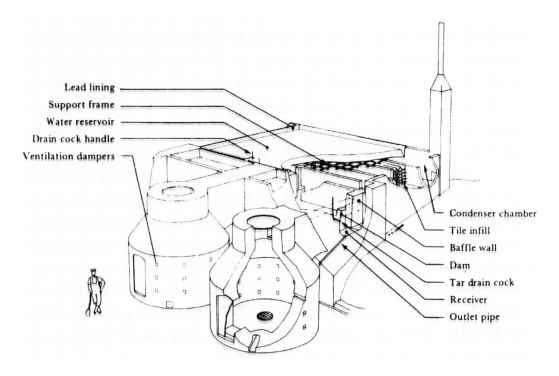

Coal Distillation
Above: The Earl of Dundonald's tar and coke ovens at the Calcutts ironworks, Jackfield, were constructed 1784–86. (Drawn by the late Derek Jobber)

Below: The coal distillation plant, part of the Priorslee Furnaces complex, was erected in 1912, producing coke and other by-products of coal until 1928.

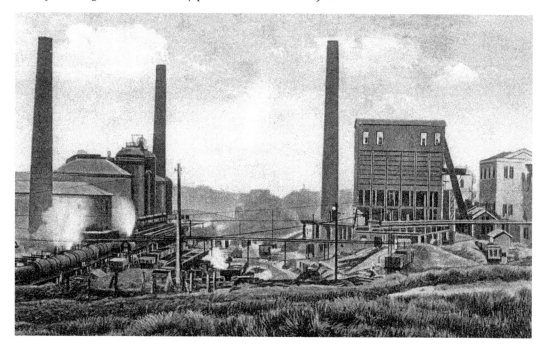

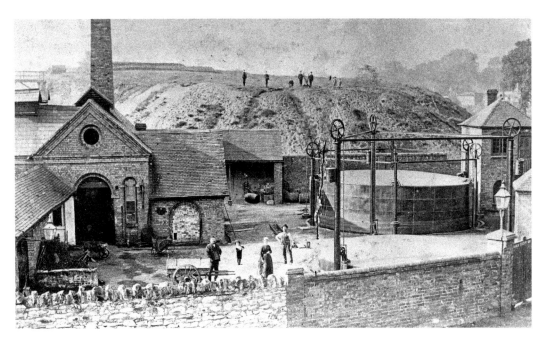

Gas Works
Above: Coal was also processed to make town gas. Most towns in the area had their own supply of gas for street lighting by the middle of the nineteenth century. Madeley gas works in Hill's Lane, built in 1852, is pictured at the turn of the century. (IGMT)

Below: Wellington had its first gas works in 1823, but the rival Wellington Coal & Gas-Light Co. of 1851 had built their second works alongside the GWR rail yard by 1870. The enlarged complex was nationalised in 1949 and was able to utilise methane pumped from Granville colliery. It became redundant following the introduction of natural gas supplies in the 1970s.

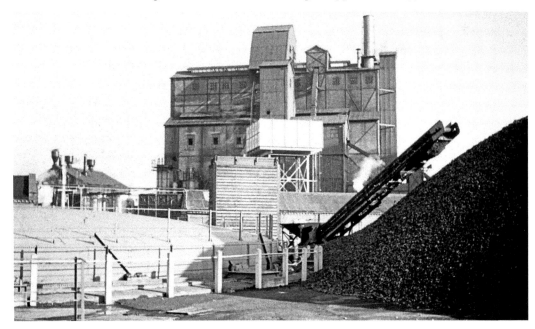

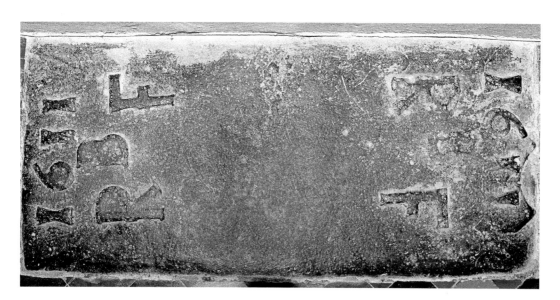

Early Blast Furnaces

Above: The indirect process for making iron in a blast furnace was introduced into this area in the mid-sixteenth century. Before 1600, charcoal-fired blast furnaces were constructed at Morville, Shifnal, Kenley and Willey. This cast-iron grave slab in Little Wenlock church, dated 1611, was probably made at one of these ironworks.

Right: In the seventeenth century charcoal-fired furnaces were erected at Leighton, Coalbrookdale, Wombridge and Kemberton. Beneath the Kynnersley Arms public house at Leighton are the remains of the furnace's tuyere (air blast) arch.

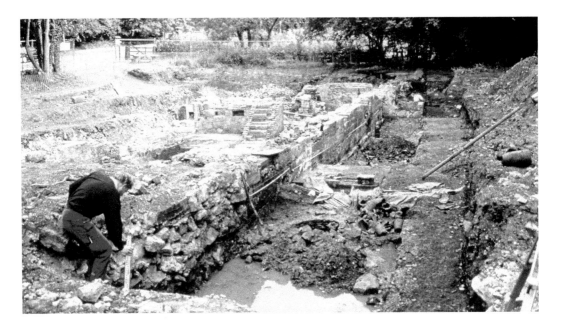

Coalbrookdale
Above: The Brooke family of Madeley Court operated ironworks in Coalbrookdale in the early seventeenth century. The remains of Sir Basil Brooke's steel cementation furnace, possibly dating from the 1620s, was recently excavated, with the landscaped site now marked by two large circles. Ordnance from the works was supplied to the Royalists at the beginning of the Civil War.

Below: The inscription on the lower beams of the forehearth of the Old Furnace at Coalbrookdale suggests it was built in 1638, but it is now felt that the furnace in fact dates from twenty years later. (IGMT)

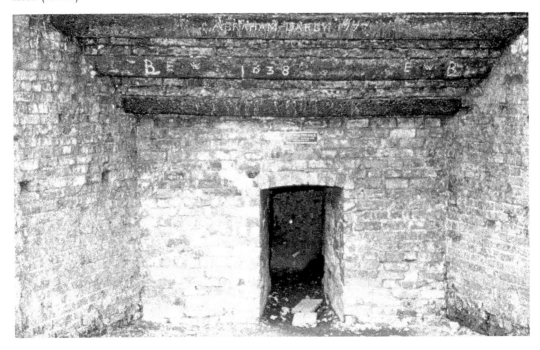

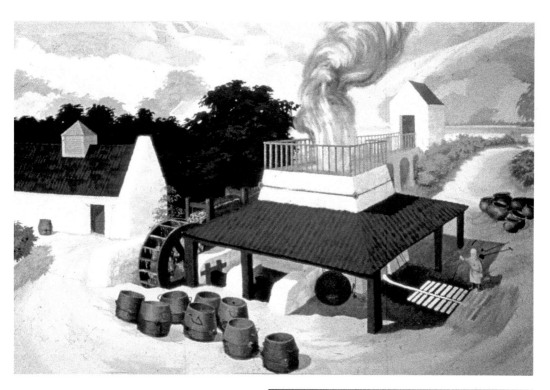

The Darbys
Above: Abraham Darby I leased and repaired the blast furnace at Coalbrookdale in 1708, and within a few years his experiments with using coke as a fuel were successful. This is an artist's impression of the works at that time. (IGMT)

Right: Early cast-iron foundry products included kitchen ware and cooking pots, but it was not until after 1750 that changes in furnace operation made coke-blast iron also suitable for forging into wrought iron. A new generation of furnaces date from that time, including those built by the second Abraham Darby at Horsehay in 1755 and Ketley in 1758. (IGMT)

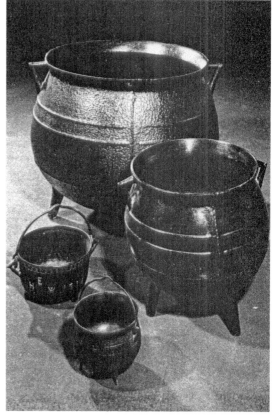

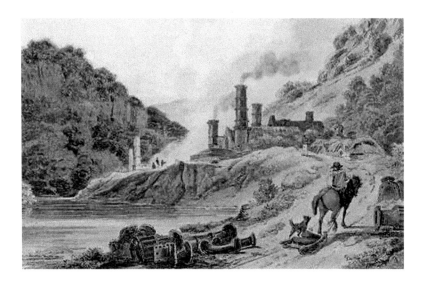

Coalbrookdale Firsts

In addition to being the first ironworks successfully to use coke to smelt iron, Coalbrookdale can also boast the status of the first to use iron to make early railway wagon wheels (1729), rails (1767) and an iron-arched bridge (1779). To provide sufficient iron for constructing some of the components of the bridge, Abraham Darby III enlarged the capacity of the Old Furnace at Coalbrookdale, but it is now thought that the large ribs were cast at his recently acquired Madeley Wood (Bedlam) furnaces (above, IGMT), which were nearer to where the structure would cross the river. The watercolour sketch by Elias Martin (below) shows the Iron Bridge under construction. (IGMT/Skandia)

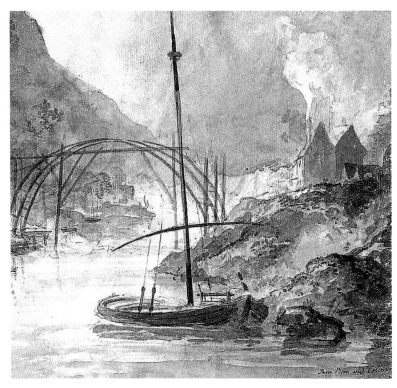

The Iron Bridge

Right: The initial design for the Iron Bridge was made by the Shrewsbury architect Thomas Farnolls Pritchard, whose portrait is shown here, and the project was vigorously promoted by Abraham Darby and John Wilkinson. (IGMT)

Below: Abraham Darby commissioned this painting by William Williams in 1780 to promote the bridge. Following the completion of the approach roads, the bridge opened for traffic on 1 January 1781. (IGMT)

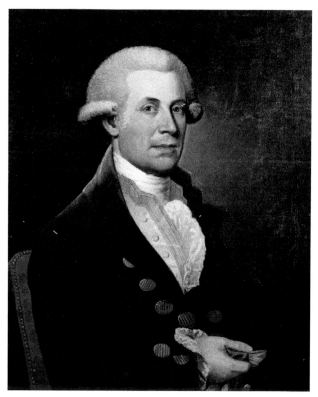

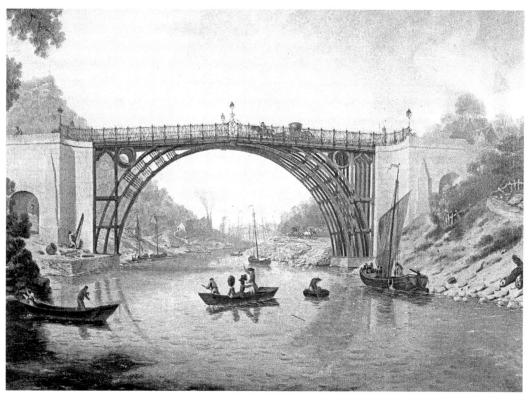

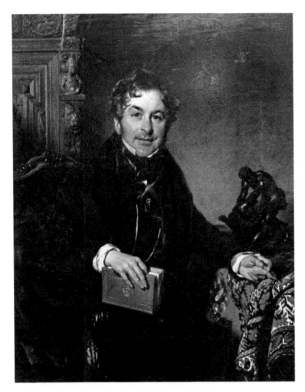

The Nineteenth Century

Following the depression in the iron industry at the end of the Napoleonic Wars, the furnaces at Coalbrookdale closed but the foundry remained in use, being supplied with iron from Horsehay, Lightmoor and Dawley Castle furnaces. In the 1830s, under the management of Francis (left, IGMT), Abraham IV and Alfred Darby, the works were reorganised and the manufacture of art castings stimulated recovery. A large display of Coalbrookdale products at the Great Exhibition in the Crystal Palace in 1851 brought great fame to the company. Examples of the company's art castings are on display in the Museum of Iron at Coalbrookdale (below).

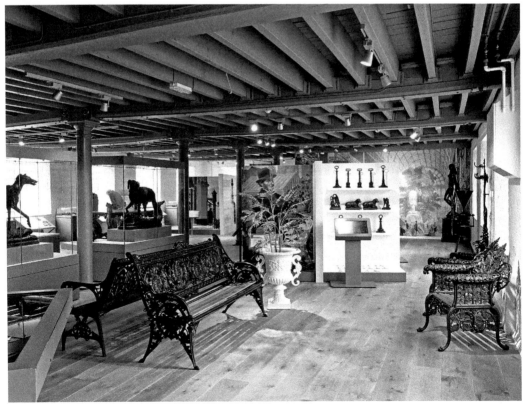

Richard and William Reynolds

Richard Reynolds moved to Coalbrookdale in 1756 and two years later became manager of the new ironworks at Ketley. In 1763 he took charge of Coalbrookdale works until Abraham Darby III came of age, overseeing the casting of steam engine cylinders, a new method for refining iron and the introduction of iron rails. (IGMT)

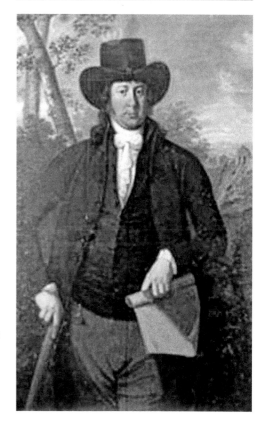

His son William followed in his father's footsteps, becoming a member of the Quaker Coalbrookdale Partnership. In 1796, the Darby and Reynolds interests separated, and William's new company continued to operate the ironworks at Ketley, Madeley Wood and Donnington Wood. The locomotive built at Coalbrookdale in 1802 by Richard Trevithick was sponsored by Reynolds, until his death a year later. (IGMT)

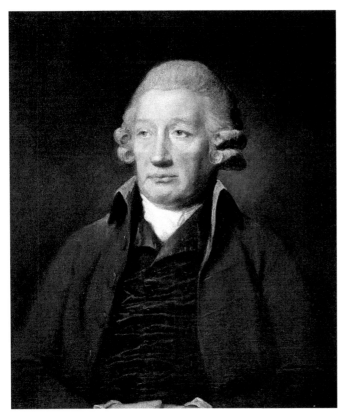

John Wilkinson
Left: Known as 'King of the Ironmasters', Wilkinson owned ironworks in South Staffordshire, the Wrexham area and North Lancashire, as well as in East Shropshire. He operated works here at Willey – where from 1757 to 1804 he introduced a series of new techniques – as well as at Snedshill, Hollinswood and New Hadley. He promoted the building of the Iron Bridge and built the first iron boat, which was launched on the Severn in 1787. (IGMT)

Below: The site of New Willey ironworks in 1971. The furnace bank is in the middle distance.

Calcutts Ironworks

Right: Begun in 1767, the ironworks on the south bank of the River Severn at Calcutts were leased by Alexander Brodie in 1786. He ceased to work the forge and concentrated on casting cannon and ships' stoves, which he supplied to the Board of Ordnance. (IGMT)

Below: The engraving of the ironworks in 1788 by George Robertson is a view looking downstream. Taken over in 1817, the works declined and, like other furnaces south of the river, had closed down by the 1830s. (IGMT)

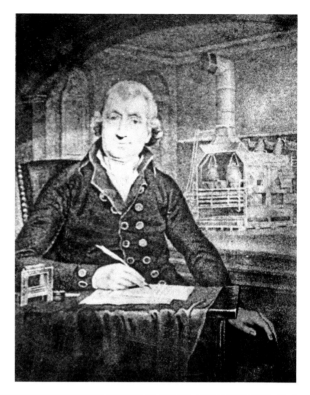

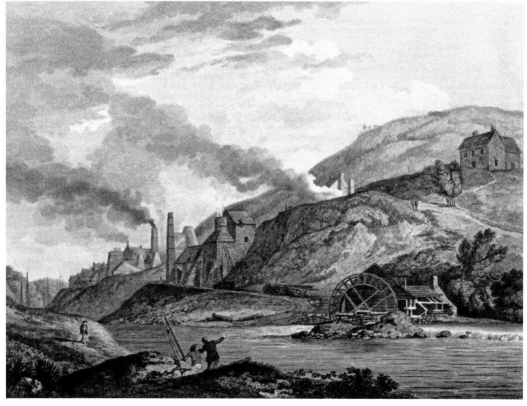

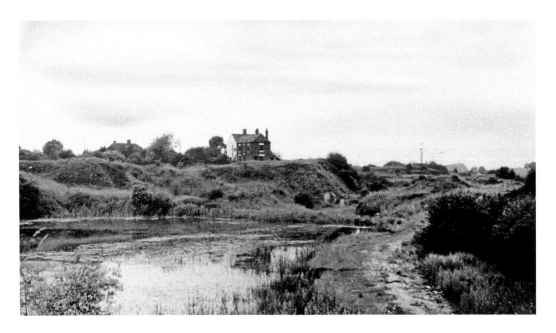

The Botfields and the Old Park Company

Above: Thomas Botfield built the Old Park ironworks in 1790, and by 1806 it had become the second largest ironworks in Great Britain. It was operated after his death by his three sons, Thomas, William and Beriah, and his grandson Beriah. The site of the works, pictured here in 1971, is now beneath the Forge Retail Park on the western edge of Telford town centre.

Below: The Botfields established further ironworks at Hinkshay, Stirchley and Dark Lane; but in 1856 the works were leased to the Old Park Company and then passed to the Wellington Iron and Coal Company in 1874. Shown is the retaining wall on the site of Stirchley Furnaces, now part of Telford Town Park.

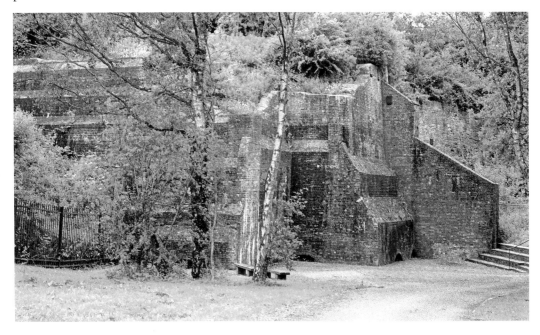

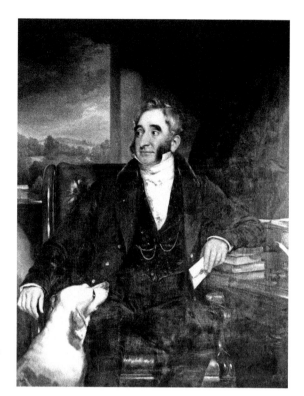

Madeley Court Furnaces
James Foster acquired the Madeley Court estate with its unexploited mineral reserves in 1827. In the early 1840s, he transferred his ironmaking activities from Wombridge to Madeley Court, where he constructed three furnaces. (IGMT)

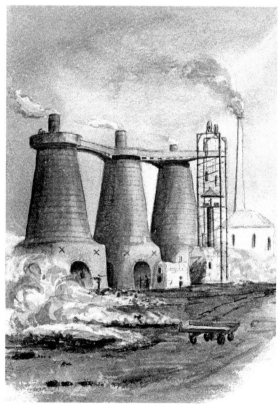

Under his successor, his nephew William Orme Foster, the furnaces continued to supply pig iron to the family's ironworks in Staffordshire and Worcestershire. They closed in 1902, but are remembered in the name of the local public house. (IGMT)

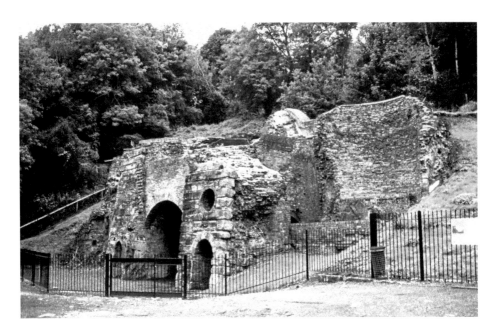

Bedlam and Blists Hill Furnaces

Above: In the early nineteenth century the Bedlam furnaces passed into the hands of the Anstice family, who set up the Madeley Wood Company. The furnaces were blown out by 1840 and ironmaking was transferred to the new furnaces at Blists Hill. The remains of Bedlam furnaces, shown here, were restored by the Ironbridge Gorge Museum Trust. (IGMT)

Below: The three furnaces at Blists Hill, erected between 1832 and 1844, produced pig iron until 1912, when the ironworks closed following a strike. (IGMT)

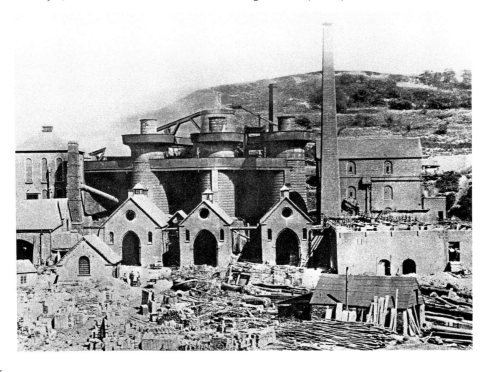

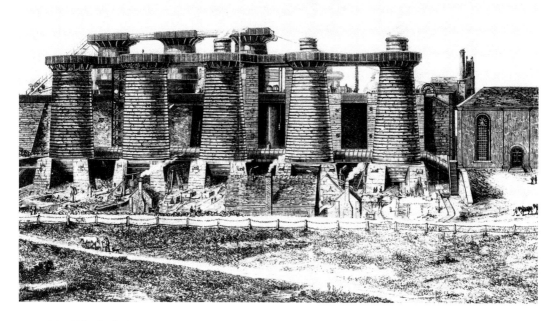

The Lilleshall Company

The Lilleshall Company, formed in 1802, became the largest industrial undertaking on the Coalbrookdale Coalfield, with ironworks, coalmines and brickworks connected by an extensive internal railway system. To existing blast furnaces at Donnington Wood, Wrockwardine Wood and Snedshill, new furnaces were added at the Old Lodge in 1825 and Priorslee in 1851.

Above: The Old Lodge in 1859, after additional furnaces had been added.

Below: The remains of the furnaces are today a feature in the Granville Country Park; they were blown out in 1888.

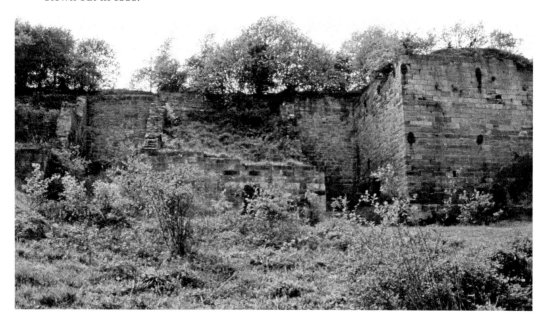

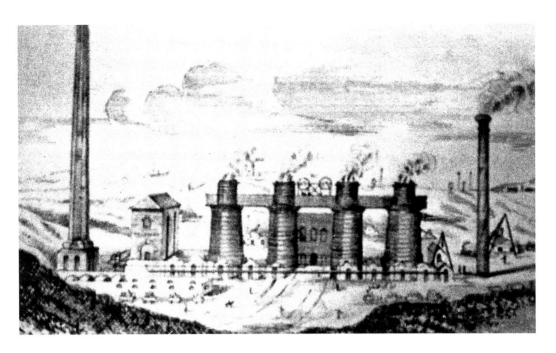

Priorslee Furnaces

Above: The four furnaces at Priorslee were erected in 1851, doubling the Lilleshall Company's pig iron production. They are shown here some twenty years after being blown in.

Below: From 1879 the furnaces provided iron for Bessemer steel and continued to operate until 1959, being at that point the very last blast furnaces in East Shropshire. This view of the Priorslee complex is dated some years prior to closure.

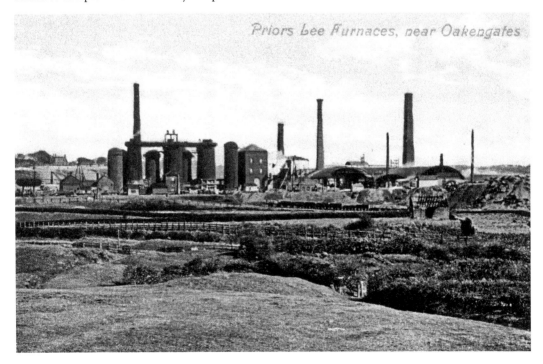

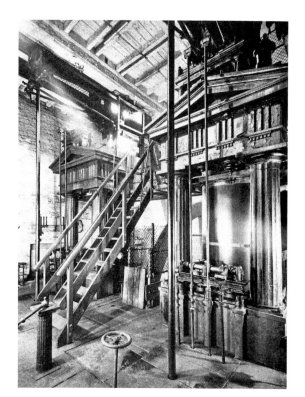

David and Sampson
The blast for the furnaces at Priorslee was provided by the two blowing engines named *David* and *Sampson* until they were replaced by more modern types in 1900. (IGMT)

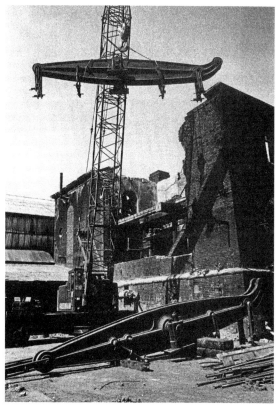

With the demolition of the blowing-engine house in the early 1970s, *David* and *Sampson* were dismantled and removed for re-erection at Blists Hill Museum. (IGMT)

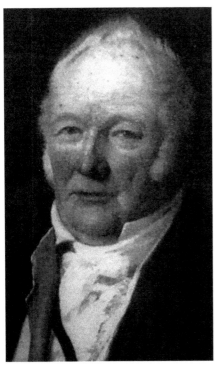

Ketley Ironworks

After closure in 1816, the former Reynolds furnaces and forge were revived two years later by the Ketley Company (one of whose partners was Henry Williams, left), producers of pig and bar iron. This company collapsed in 1874, but engineering returned to the site in 1903 when the Sinclair Iron Co. was established to make castings for the building trade (below, IGMT). In 1929 the works became part of Allied Ironfounders and, forty years later, Glynwed Foundries, making automobile castings and cast-iron rainwater, soil and drain pipes and gutters. Part of the site is now occupied by St-Gobain PAM UK Ltd, suppliers of ductile iron and cast-iron products.

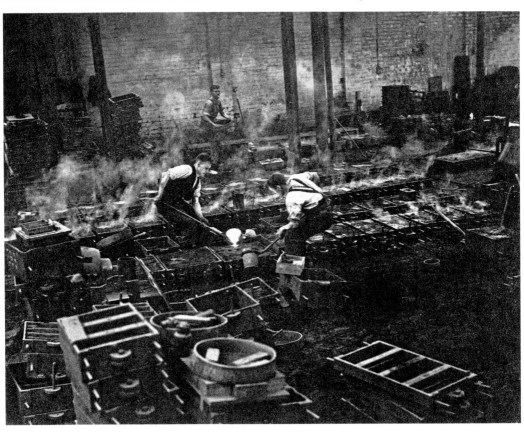

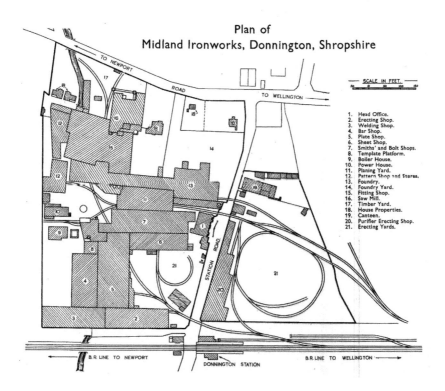

C. & W. Walker

Above: C. & W. Walker established the Midland Iron Works at a railside site in Donnington in 1857. They specialised in making gas-purification plant and gas holders, eventually becoming one of the world's leading suppliers of gas equipment. When coal gas was superseded by natural gas in the 1960s, the company became specialists in containers for other gases, the oil and chemical industries, and grain. Gradually reducing in size, the works closed in the late 1970s.

Below: The company's head office in Station Road, Donnington, before demolition. In 1979, the clock tower was re-erected on the nearby site of Donnington station, which is now a roundabout.

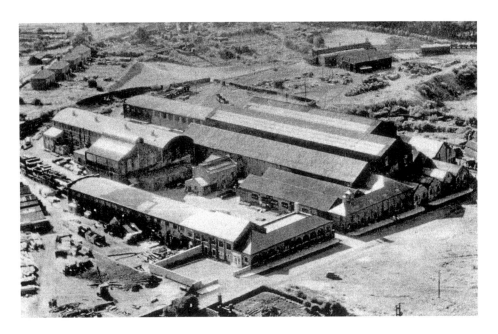

New Yard
Above: The Lilleshall Company's New Yard engineering works at Wrockwardine Wood opened in 1861, and at first manufactured locomotives and blowing engines. It began to produce large gas engines in the early twentieth century, and reached peak production at the time of the First World War, when heavy munitions work was undertaken. Lack of orders led to closure in 1931 and the letting of the premises; but war contracts revived New Yard during the Second World War. In its final period of operation in the second half of the twentieth century, it was particularly noted for its steel building structures. (IGMT)

Below: Today, the only reminder of the works is the former offices' frontage in Gower Street.

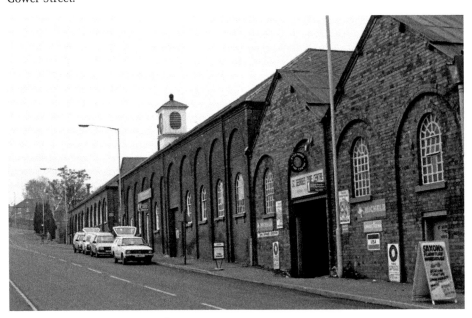

Horsehay Works
Above: The Coalbrookdale Company's Horsehay furnaces were blown out in 1862 and the forge and mills closed in 1886. The works were taken over by the Simpsons, who developed the heavy engineering side of the business, concentrating on the manufacture of bridges, roofs and girders, and at the beginning of the twentieth century specialising on making gas plant. (IGMT)

Below: Taken over in 1948 by Adamson Alliance (later Adamson-Butterley), the works manufactured heavy and travelling cranes, bridges and mining equipment. Downsizing by the new parent company, AB Cranes, led to closure in 1985. (IGMT)

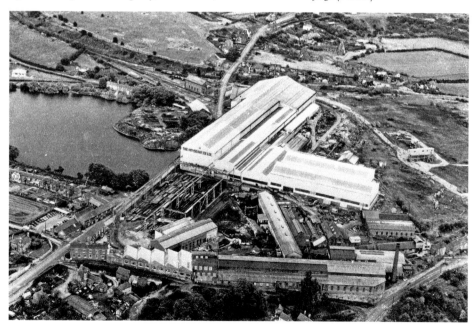

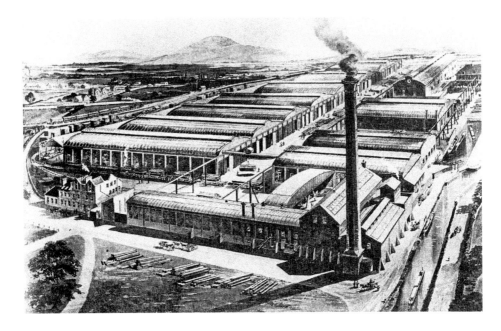

Castle Works, Hadley

Above: Originally opened as Castle Iron Works by Nettlefold & Chamberlain in 1871 and producing wire and bar iron, it closed in the late 1880s. The works were taken over in 1900 by G. F. Milne, Birkenhead, whose new Castle Car Works manufactured tramcars for the next four years. The Metropolitan Amalgamated Railway Carriage & Wagon Co. followed briefly, but Joseph Sankey & Co. bought the works in 1910 to make motor vehicle wheels and body parts. (IGMT)

Below: A recently rescued Hadley-built Milne's tramcar, awaiting restoration at Telford Steam Railway, Horsehay.

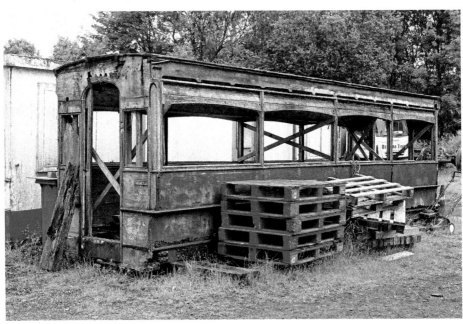

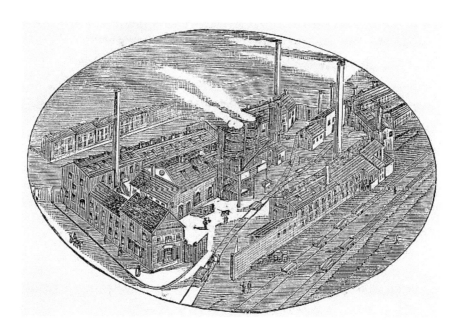

Maddock's Foundry
Above: Beginning as a nail factory at Stirchley in 1869, the plant moved to Oakengates in 1878 when John Maddock & Co. was founded. Manufacturing a variety of cast-iron products, the works expanded from its railside site into Station Road. In 1938 the company acquired the Lilleshall Co.'s old Snedshill works on Canongate and became one of the largest foundries in the area. It was taken over by William Lee Ltd in 1980, when parts for commercial vehicles were the main product, but closure followed four years later.

Below: The former Wesleyan Chapel in Station Road, Oakengates, became the John Maddock office building in 1919.

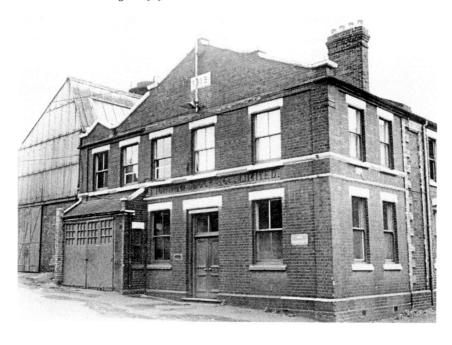

Court Works

Left: Known locally as Parker's, after its founder (electrical engineer Thomas Parker), this foundry took over the premises of Madeley Court furnaces in 1912. It specialised in castings for the motor and electrical industries. Sold by Charles Parker in 1925, the works underwent several ownership changes in the following years, but continued in operation until the late 1980s, then being converted into an estate for industrial units. (IGMT)

Below: This is the entrance to the works, opposite the Three Furnaces public house, in 1971.

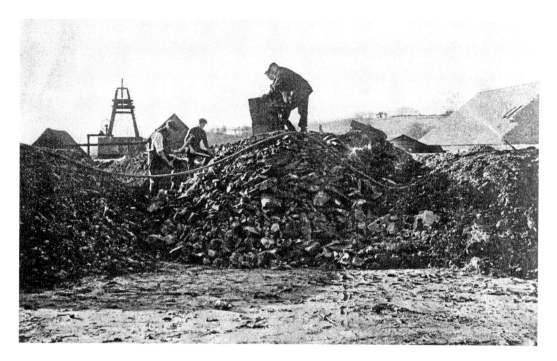

Brickmaking

Above: Before clay could be used, it had to be 'weathered' for three months. This early 1930s photograph shows the watering, weathering and turning of the clay obtained from Blists Hill Mine, which can be seen in the background. (IGMT)

Below: The remains of Legge's brickworks at Blists Hill, built by the Madeley Wood Co. in 1851. At the brickworks the weathered clay was put through a pug mill and fed into moulds, and the resulting bricks were dried and then fired in kilns. The works closed in the early 1940s.

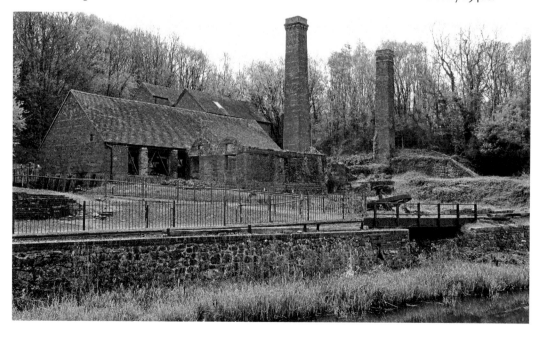

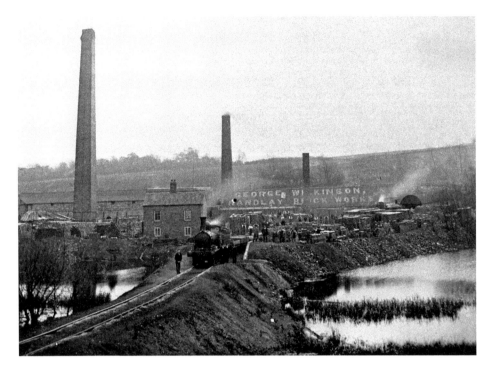

Randlay Brickworks

Above: A brickworks at Randlay had been established by the Botfields in 1838. The works was leased by the Haybridge Iron Co. to George Wilkinson who, in partnership with Adam Boulton, formed the Randlay Brick & Tile Co. in the 1890s, with clay being obtained from an adjacent extensive pit (view looking east). (IGMT)

Below: The works became A. Boulton & Co. from 1939, increasing its output of bricks, but finally closed in the 1970s as a result of the designation of Telford New Town (view looking west). (IGMT)

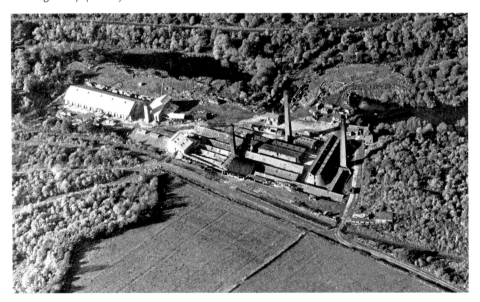

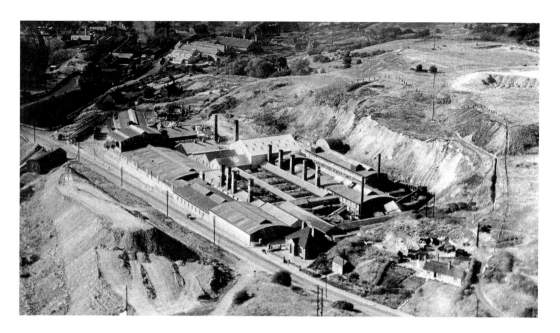

Snedshill Brickworks

Above: The Lilleshall Co. had established a brickworks at Snedshill (Oakengates) by 1850, making red bricks, tiles, quarries, white bricks, fire bricks and land drainage pipes from fireclay, which it got from its own pits. In the early 1900s, the brickworks were improved.

Below: The output of salt-glazed pipes, refractories, glazed bricks and sanitary ware was expanded in the 1930s. Post-Second World War, a supply problem with deep-mined clay and competition from plastic and stainless steel sinks led to the end of ceramic production in 1977.

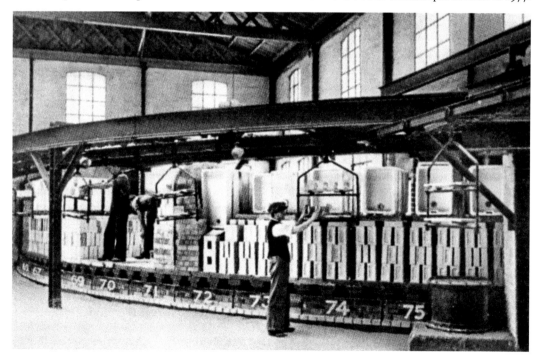

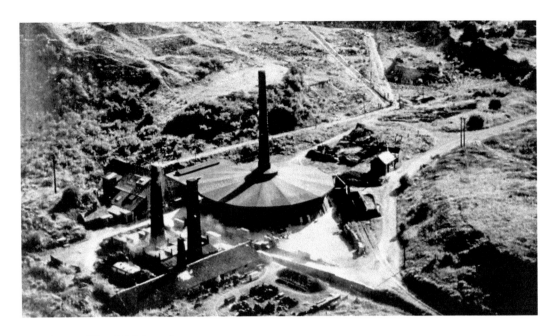

Donnington Wood Brickworks

Above: Brickmaking in the Donnington Wood area became concentrated at this mechanised brickworks, which was opened by the Lilleshall Co. in 1872. The works had a distinctive circular Hoffmann kiln and ample supplies of high-grade red marl. It produced excellent building bricks, but these proved expensive after the Second World War and the works eventually closed in 1972. (IGMT)

Below: This is the chain-operated railway for hauling tubs of clay from the clay pit, which is shown in the middle background of the above photograph.

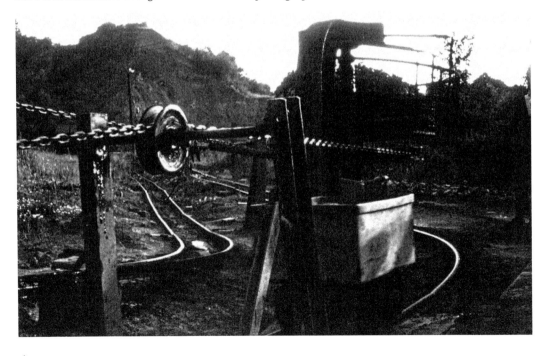

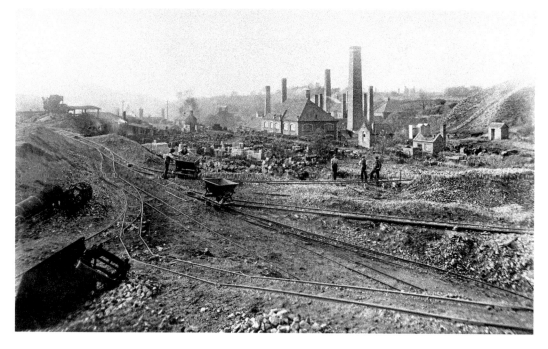

Lightmoor Brickworks
Above: One of three large brickworks operated by the Coalbrookdale Co., the Lightmoor works was in existence by 1852, using local red clay and fireclay. The extensive brickfield at Lightmoor is shown in this 1920s photograph. (IGMT)

Below: The brickworks was taken over by Coalmoor Refractories in 1951, but had closed by the late 1980s.

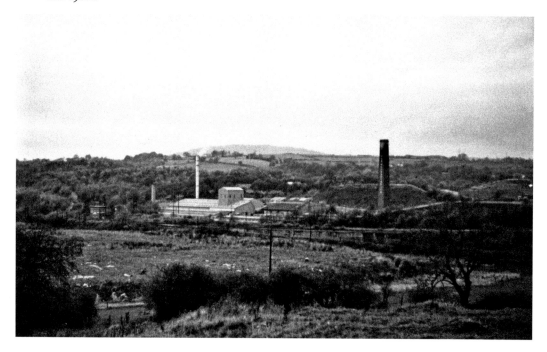

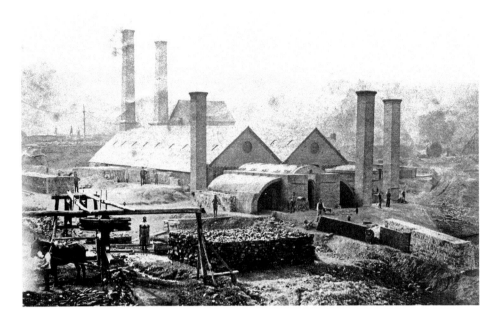

Milburgh Tileries
Above: Brick and tile-making in and around Broseley dates from the eighteenth century, utilising deep clay found in the Jackfield area. Peak production was reached in the second half of the nineteenth century, when up to ten works were operating, mostly in Jackfield, making roofing tiles. Milburgh Tileries, founded by Thomas Prestage, was open between 1870 and 1938.

Below: Following closure the works was abandoned, but in the 1970s much of the plant, including the pug mill, was moved to Blists Hill Museum. (IGMT)

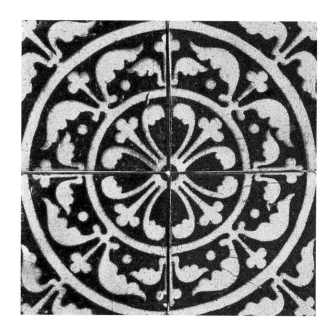

Decorative Tiles

The manufacture of decorative (encaustic) tiles became a major industry in the Ironbridge Gorge in the late nineteenth century. Tiles produced by Maw and Craven Dunnill were used for church floors, shop counters, the fronts of public houses and porches of villas in all parts of Britain and in public buildings abroad.

Above: 'Ancient' floor tiles closely following medieval design, made by Craven Dunnill & Co. in 1880. (IGMT)

Below: Glazed tiles decorated with transfer prints, made by Maw & Co. in 1885. (IGMT)

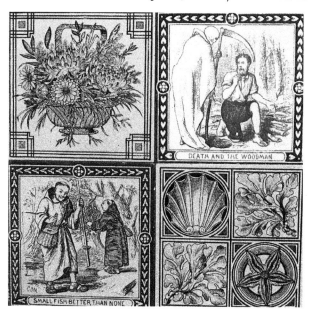

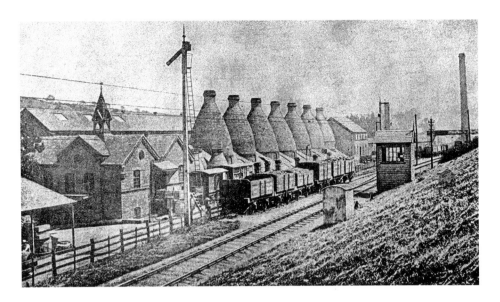

Maw & Co.

Maw & Co. was founded in Worcester in 1850 by George and Arthur Maw, who obtained their clay by river from the Ironbridge Gorge. They moved their works to Benthall two years later, but transferred from their cramped former ironworks site to Jackfield in 1883.

Above: This became the largest decorative-tile factory in the world. As well as making floor tiles, the company built up a large range of glazed tiles for walls, porchways, fireplaces and washstands, but a slowdown in the industry and a series of takeovers resulted in closure in 1969. (IGMT)

Below: The remaining buildings, including the entrance, are now used as craft units.

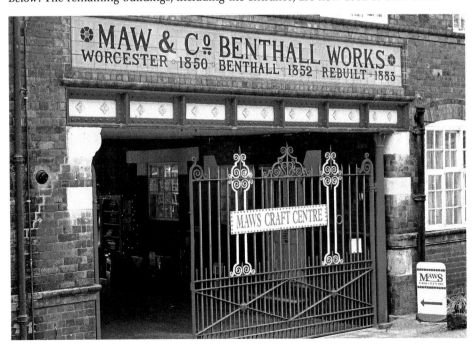

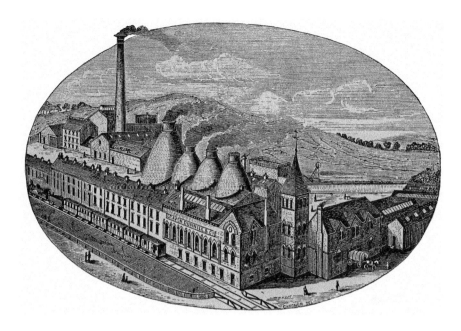

Craven Dunnill

Above: The company, founded in 1870 as Hargreaves, Craven & Dunnill, rebuilt their existing site to form the new Jackfield Encaustic Tile Works in 1874. They became particularly well known for their wide range of medieval-type encaustic tiles for use in new and restored churches. (IGMT)

Below: The works closed in 1952 and the buildings were taken over and used by precision engineers Marshall Osborne until 1982. It later became the IGMT's Tile Museum.

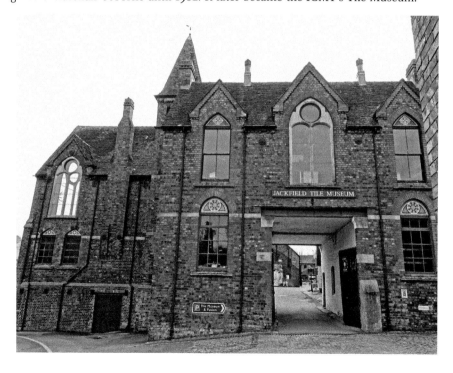

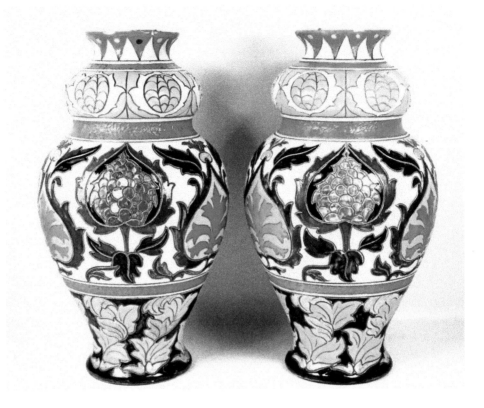

Potteries

Above: The earliest pot works in the Jackfield area date from the early seventeenth century. Benthall Pottery, founded by John Thursfield in 1772, became the main pot works in the area. It changed ownership several times during the early nineteenth century, but it continued to produce the traditional coarse 'red-and-yellow' ware. After 1862, the company was run by the Allen family, who began to promote the works as the Salopian Decorative Art Pottery Co., producing pieces such as these.

Below: Briefly reverting to producing coarse ware, after 1930 the works was used by the Benthall Pipe Co. to make agricultural and sanitary pipes, finally closing in 1987.

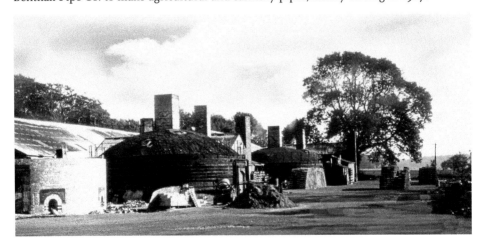

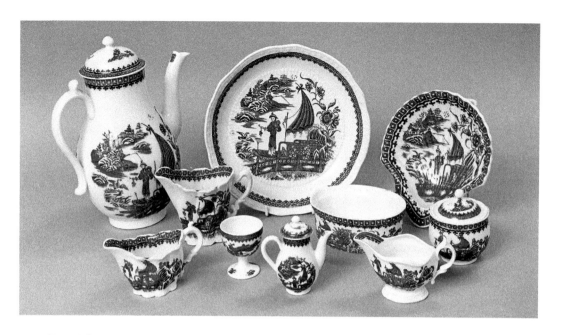

Porcelain

Porcelain manufacture in Shropshire began in the second half of the eighteenth century at Caughley (near Broseley) and Coalport, and continued at the latter factory for over a century. Its roots lay in the availability of supplies of coal and clay, the earlier earthenware tradition of the Jackfield area, links with the porcelain industry in Worcester and the proximity of the River Severn. A selection of blue-and-white Caughley porcelain can be seen above (Caughley Society) while a display of Coalport porcelain at the IGMT's Coalport China Museum can be seen below.

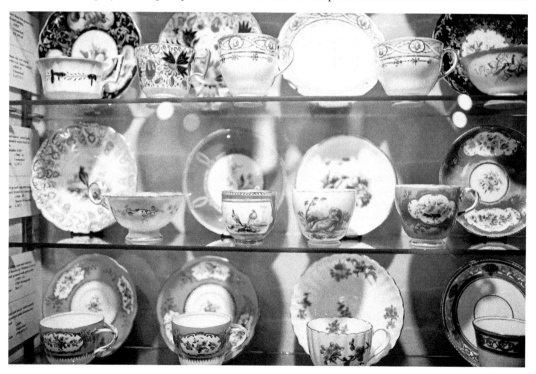

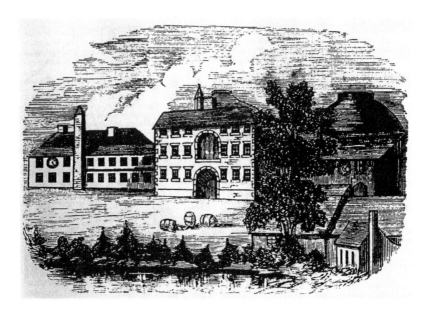

Caughley

Above: Taking over an earlier pottery, Thomas Turner from Worcester had established the Salopian Porcelain Manufactory at Caughley by 1775, using soapstone (and later china clay) from Devon and Cornwall. The blue-and-white Oriental-style patterns that were introduced by Turner were applied by under-glaze printing. Caughley was a great success until the 1790s, when a former employee, John Rose, set up in competition at Coalport. Rose took over Caughley in 1799 and closed the works in 1814.

Below: Within six years, the buildings were taken down, and any remaining features were destroyed by opencasting in the 1960s. This commemorative obelisk marks the site.

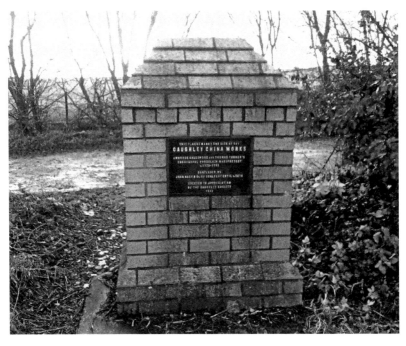

John Rose

Right: John Rose and partners established their Coalport factory on the north side of the recently opened Shropshire Canal in 1795 and absorbed the factory on the other side of the canal in 1814. The next twenty years saw some further expansion and significant technical developments, such as the use of a lead-free glaze. The works produced a variety of tableware and went on to make a distinctive style of flower-encrusted decorative pieces. (IGMT)

Below: Coalport China Works in the early nineteenth century, with the River Severn in the foreground and the Shropshire Canal running between the buildings. (IGMT)

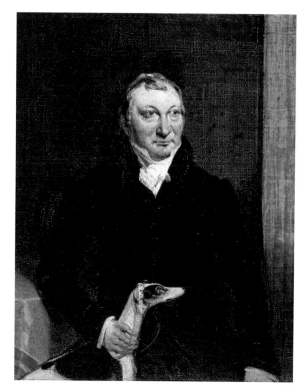

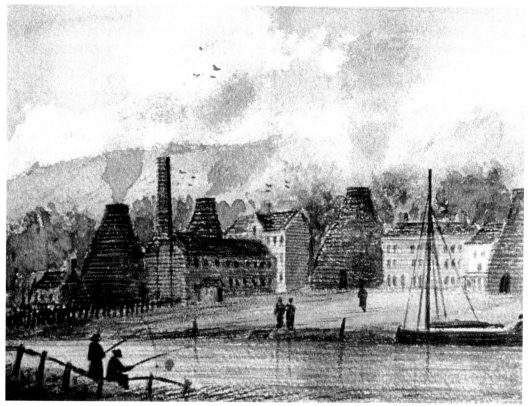

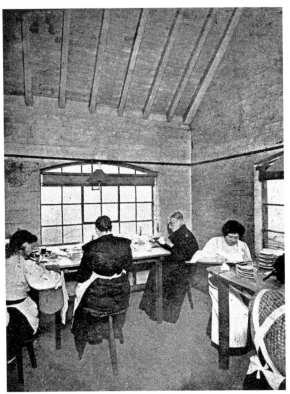

Coalport
The company continued to thrive after Rose's death in 1841, but decline set in after the manager, William Pugh, died in 1875. There was a period of recovery after 1888 under the new owner, Charles Bruff. These women painters (left, IGMT) were at work at that period, but increasing competition from Staffordshire and a takeover led to the closure of the works in 1926. Today it forms the IGMT's Coalport China Museum (below).

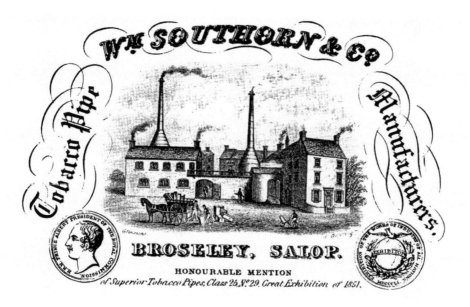

Tobacco Pipes

Above: Clay tobacco pipes were made in Broseley from the beginning of the seventeenth century, using initially local white clay but then Devon white clay brought up the River Severn by the late eighteenth century. At first a cottage industry with more than fifty small firms, by the mid-nineteenth century it was concentrated in a few local works, with Smithemans and Southorns being the major operators. This is Southorn's works on Legge's Hill.

Below: Henry Southorn bought out Smitheman's Crown Works in King Street in 1926 and pipes were made there until the late 1950s. The abandoned works were later restored as a pipe museum by the IGMT.

Limeworks

Limestone was mined and quarried in four main areas in East Shropshire: Lilleshall, Steeraway, Lincoln Hill and Wenlock Edge.

Above: At Steeraway and the adjacent Little Wenlock quarries, limestone was worked for flux for the iron industry and lime for agriculture. These are the remains of four kilns that produced lime at Steeraway.

Below: The extensive Lea Quarry was one of the last working quarries on Wenlock Edge. It opened in 1943 and its southern extension closed in 2007.

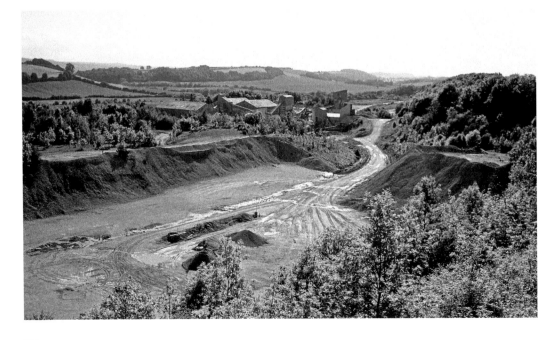

Glass and Chemicals

Above: Glass had been made in the Coalfield around 1700 at Snedshill and Broseley, but it was not until William Reynolds established a glassworks on the north bank of the Wombridge Canal at Wrockwardine Wood in 1792 that the industry took off. Local raw materials, including slag, were used, and the principal products were crown glass and dark green bottles for the French wine trade. The works closed in 1841.

Below: The site of Stirchley furnaces was acquired by Thomas Groom, the Wellington timber merchant, who in 1886 transferred his Wrekin Chemical Works from Steeraway. From timber supplied from Groom's Wellington yard, wood naphtha, tar, lime salt, sulphur and charcoal were made. The works closed in 1932, but its tall chimney (at 209 feet) remains. The processing of slag for road aggregate continued on the adjacent site until 1964.

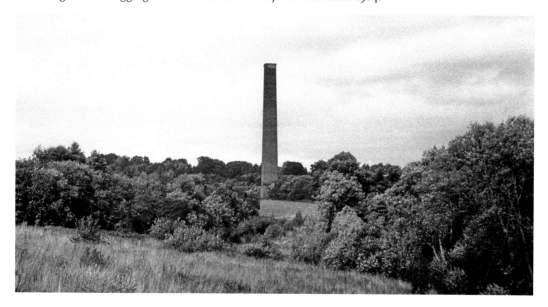

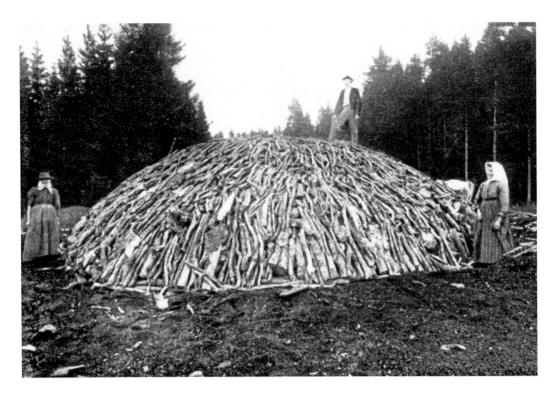

Wood Products

Above: Before the introduction of coal (as coke), iron furnaces used charcoal as a fuel. Wood was slowly burnt in heaps covered with turf for five days to produce charcoal. There is evidence of numerous charcoal-burning sites on the Wrekin. The photograph shows a wood pile before it was covered with turf or soil and fired, in around 1890.

Below: The railside yard of Richard Groom & Son, 'Timber Merchants, Saw-mill Owners and Woodware Manufacturers', handled large consignments of timber from local sources and further afield. One of Wellington's most successful businesses, it finally closed in 1970.

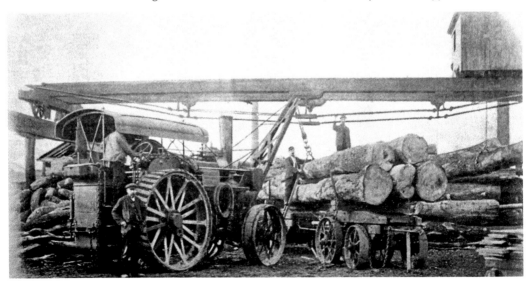

Chains and Machinery

Above: Benjamin Edge, at his new Coalport Works, invented and manufactured a new type of flat chain in 1800, which soon superseded hemp rope in pit-head winding apparatus. Moving to a railside site in Shifnal in the early 1870s, Edge & Sons made chains and wire ropes, which were exported worldwide. Sold to British Rope Ltd during the Second World War, the works closed in 1972.

Right: Samuel Corbett set up at Park Street, Wellington, as an agricultural implement maker in the early 1850s, and within twenty years the business was flourishing. At the turn of the century, Corbett's were among the country's best known manufacturers of agricultural machinery, and they continued in the town until 1974.

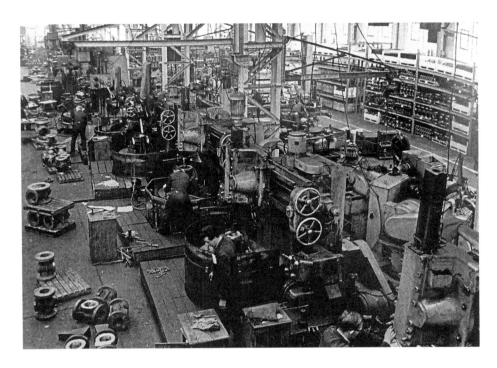

Valves and Batteries

Above: Beginning in 1896 on the site in Newport of the premises of William Underdale, who manufactured and repaired agricultural machinery, the firm became the Audley Engineering Co. in 1906. At first making iron valves and plugcocks, they eventually produced a range of valves for the oil and chemical industries. Known as Serck Audco Valves from 1970, the works closed in 2002. (*Shropshire Star*)

Below: The Ever Ready factory at Hinkshay, a satellite of the company's Wolverhampton base, opened in 1956. It produced dry cell batteries and at its peak employed almost 2,000, mostly female, workers. After a number of takeovers, the factory closed in 1994. (*Shropshire Star*)

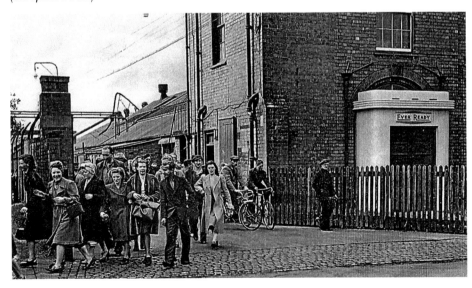

Cattle and Leather
Above: There was a tannery in Walker Street, Wellington, in 1690 and the neighbouring Tan Bank is said to have been the site of another. Only the street name is a reminder of this.

Below: Originally a cattle fair held on the Green, Wellington's livestock market began in 1855 on a railside site south-east of the station, provided by the auctioneer John Barber. It was replaced in 1868 by a new Smithfield, next to the railway off Bridge Road, which was provided by the Market Co. The weekly Monday fatstock market operated successfully for the next century, finally closing in 1989.

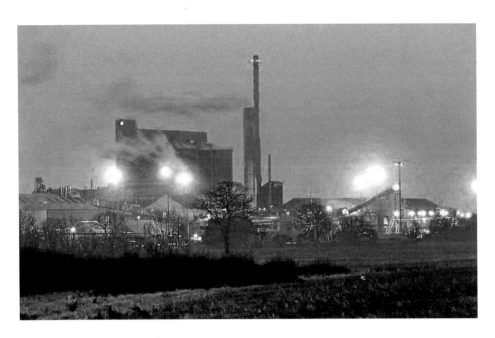

Sugar Beet and Dairy Products

Above: The sugar beet factory at Allscott, opened in 1927, processed beet from local farms and from further afield, which was transported to the plant by road and rail. This dramatic view of the factory was taken in its heyday at dusk; it closed in 2007. (*Shropshire Star*)

Below: The dairy factory and creamery at Crudgington, originally formed as a cooperative in the 1920s, was taken over by the Milk Marketing Board in 1935 and eventually operated under the Dairy Crest name, producing butter and spreads. The plant closed in 2014 when production was transferred to Dairy Crest's Kirby (Liverpool) factory. (*Shropshire Star*)

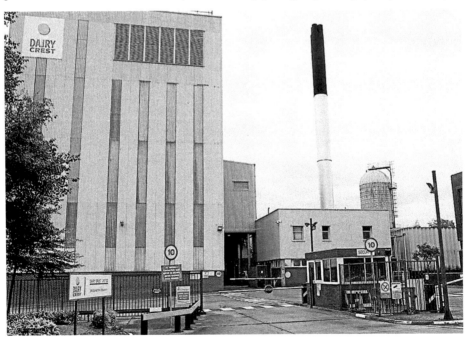

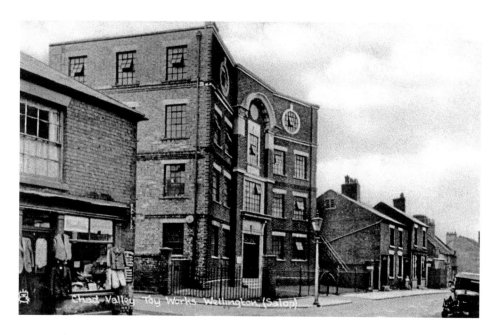

Toys and Garments

Above: The Wrekin Toy Factory was established in the former Wesleyan Methodist Chapel in New Street, Wellington, in 1916. By 1922 it belonged to Chad Valley Co., who added the distinctive curved frontage. Successful for over fifty years, it finally closed in 1975. One former employee, Nora Wellings, founded the Victoria Toy Works in King Street, making dolls, and another helped establish Merrythought, soft toy makers, at Dale End, Ironbridge.

Below: Pyjamas Ltd (Clifford Williams and partners) took over premises in Ironbridge for garment-making in the early 1950s and moved to factories in Madeley and Dawley Bank (shown here) in the 1960s. They later located to the Halesfield and Stafford Park industrial estates, and had closed by the 1990s. (*Shropshire Star*)

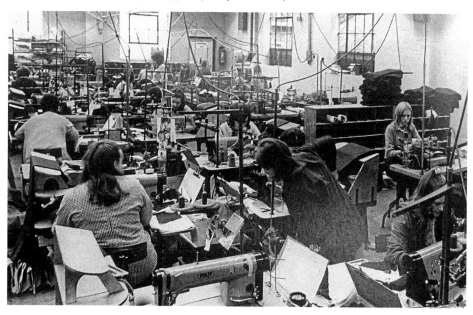

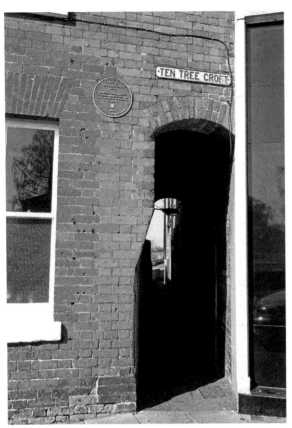

Cloth and Carpets

Left: In the seventeenth and eighteenth centuries, spinning and weaving were carried on in and around Wellington, mostly at a domestic level, using local hemp, flax and wool. Cloth manufacture had probably ceased by the early nineteenth century, but drapers, tailors and clothing retailers continued to operate in the town. The passageway Ten Tree Croft (from 'tenter croft', an area containing frames on which cloth was stretched to dry) is a reminder of this early industry.

Below: Carpet weaving began in Bridgnorth before the nineteenth century, but the Friars Carpet Works alongside the River Severn, founded and operated by the Southwell family from the 1820s to the Second World War, was the largest carpet manufacturer in the town. Later run from Kidderminster, it had closed by the 1980s.

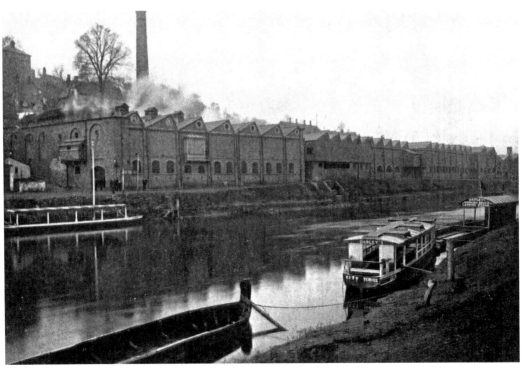

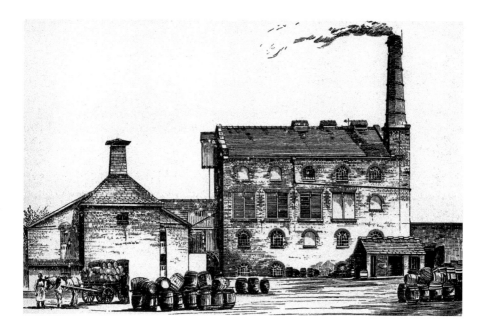

Brewing

Above: There were a number of maltings in East Shropshire by the eighteenth century, supplying local public houses that brewed their own beer. The first purpose-built brewery in the area was established in 1851 on Holyhead Road, opposite the Old Hall, Wellington, and others followed.

Below: The Wrekin Brewery, established in Market Street in 1871, was taken over by the Murphy family, who controlled it from 1921 to 1966. O. D. Murphy & Sons sold the business, which included over 200 public houses over a wide area, to Greenall Whitley of Warrington. The Market Street premises closed in 1969 and were demolished. (IGMT)

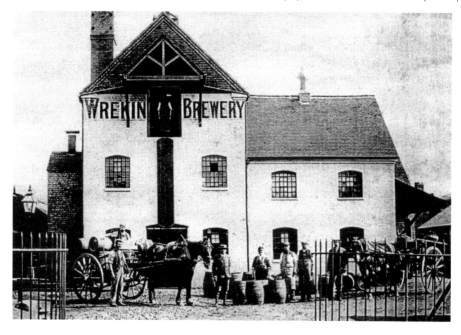

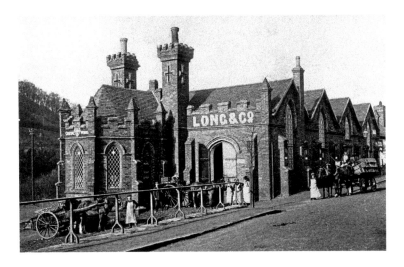

Mineral Water

Above: By the late nineteenth century, mineral water was manufactured at Bridgnorth, Ironbridge, Oakengates, Shifnal and Wellington, in some cases using water from Admaston Spa. The mineral water business of Long & Co.'s Crystal Works, operating in the former riverside warehouse of the Coalbrookdale Co., was taken over by O. D. Murphy in 1904. (IGMT)

Below: O. D. Murphy supplied soft drinks to public houses and other outlets, and in 1907 relocated to Wellington, where over the next few years he acquired a number of mineral water works, including the Ensor premises in Market Street, which are shown here. He also took over the former brewery site on Holyhead Road, but there he was not allowed to brew beer, so he used it as a bottling plant for firms such as Guinness.

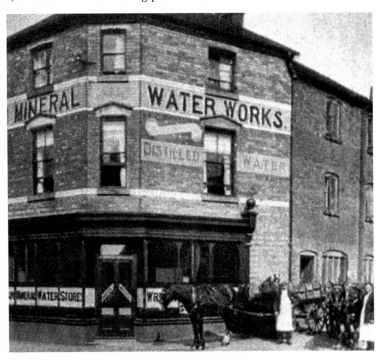

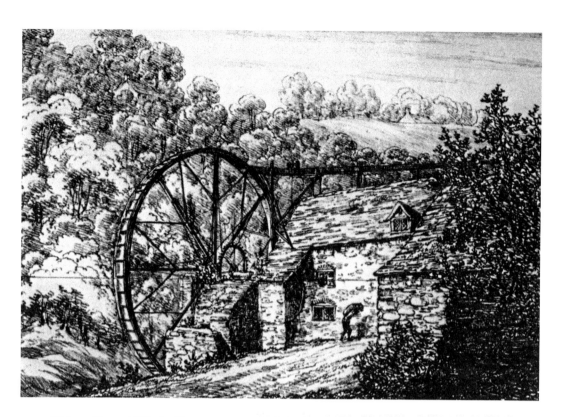

Watermills and Windmills

Above: A water mill for grinding corn was built on the Benthall Brook, near its confluence with the River Severn, in the late eighteenth century. Its 60-foot-diameter overshot wheel, together with the adjacent Iron Bridge, attracted tourists and artists. Used only occasionally by 1900, it was dismantled in 1935. (IGMT)

Right: The windmill on the outskirts of Much Wenlock dates from the early eighteenth century. It was wrecked by lightning around 1850, but the stone tower remains.

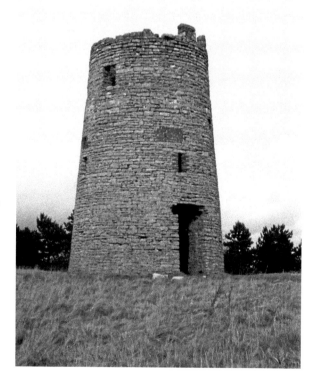

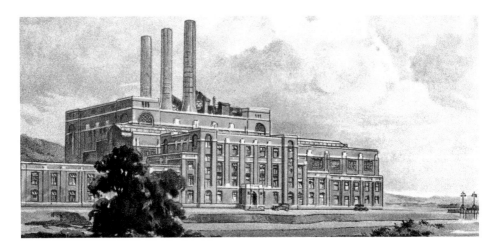

Electricity Generation
Above: Together with supplies of local coal and a rail link, the availability of an abundant supply of water was a major factor in siting an electricity generation station on the south bank of the River Severn at the eastern edge of the parish of Buildwas. Opened in 1932, and eventually generating 200 megawatts, it enabled the West Midlands Joint Electricity Authority to bring electric power to Newport, Shifnal, Wellington and Much Wenlock.

Below: A larger station, Ironbridge B, was commissioned in 1969, and when the older station was run down by 1978, the new station began to generate at full 1,000 MW capacity. Ironbridge A was demolished in 1983 and Ironbridge B closed in 2015.

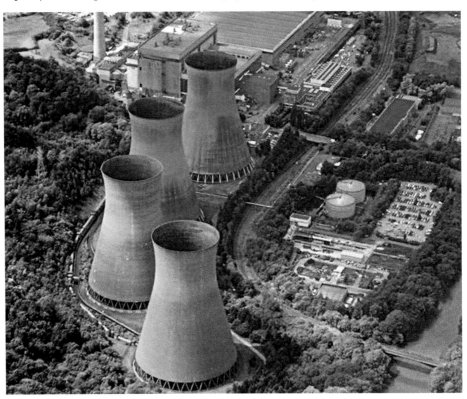

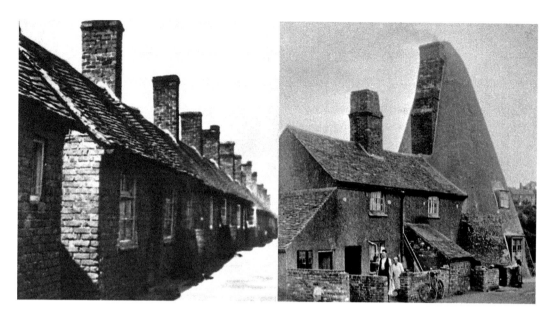

Industrial Housing

Most of the early industrial enterprises on the Coalfield provided housing for their workers, particularly if the workforce had to be brought in from outside the area.

Above: These early single-storey 'barrack' houses of the Lilleshall Co. at Donnington Wood were demolished in the 1970s. The long-gone Round House at Horsehay was a converted kiln that was once used to make the clay pots needed for making wrought iron at the nearby works.

Below: Foster's Row (seven blocks of four cottages, later numbered 22–49 Aqueduct Road) was built in the 1840s by the ironmaster James Foster for employees working at his Madeley Court mines and blast furnaces.

Part III: Industry Today

Today there is possibly a greater variety of industrial activity within East Shropshire than there ever was in the past, but it is of a very different character. Mining and heavy industry have been replaced by a range of light engineering, technical, food and service industries, and this newer industrial activity has been concentrated on industrial estates and business parks. However, a handful of older industries have survived, including Aga cookers at Ketley, GKN Sankey at Hadley, Blockley's brickworks at New Hadley/Trench Lock, and Leaton quarry at Wrockwardine. Brewing and the making of encaustic tiles at Jackfield have been revived on a modest scale, and soft toy manufacture is still carried on by Merrythought Ltd at Ironbridge. The newspaper and tourist industries also have their roots in the past.

The largest concentration of industrial estates and business parks is within Telford, where six sites were designated for such use when the New Town area was enlarged in 1968 – Halesfield, Heath Hill, Hortonwood, Stafford Park, Trench Lock and Tweedale. In fact, the first industrial estate had already been laid out at Tweedale and the first factory occupied two years previously (*below*). Outside Telford, industrial estates and business parks have also sprung up at Bridgnorth, Broseley, Much Wenlock, Newport and Shifnal.

As well as the different character of modern industrial activity in East Shropshire, few local resources are now used in the manufacturing processes. The movement of goods, whether raw materials or products, has been by road haulage since the 1960s, with the completion of the M54 in 1983 providing a vital link to the national motorway network. The only regular rail-borne traffic in recent years has been that to Ironbridge Power Station, which ended with the closure of the plant in 2015. The potential of the rail freight terminal at Donnington has still to be realised.

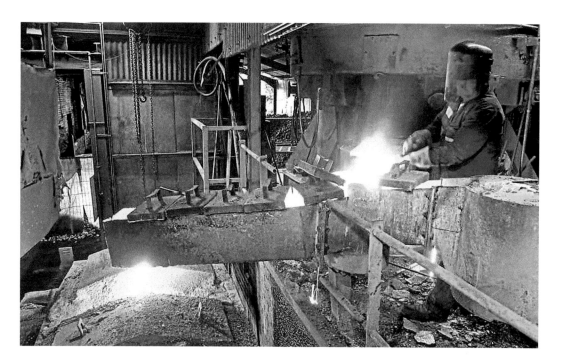

Aga

At the beginning of this century, the Aga-Rayburn division of Glynwed Appliances Ltd became part of the Aga Rangemaster Group. With 120 employees at its historic Coalbrookdale foundry (above, *Shropshire Star*) and a further 300 at its Ketley factory, where it designed and manufactured its well-known range of cookers, Aga was taken over by the Illinois-based Middleby Corporation in 2015. In spite of drastic staff reductions, and the closure of the Coalbrookdale foundry in 2017, production continues at Ketley (below).

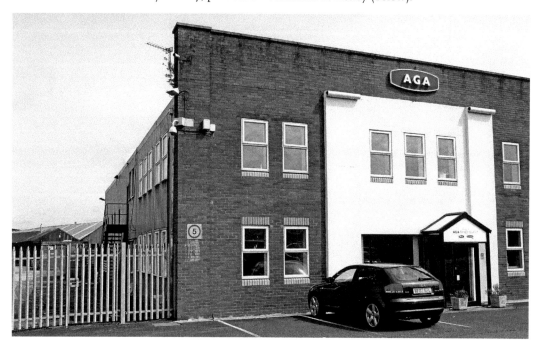

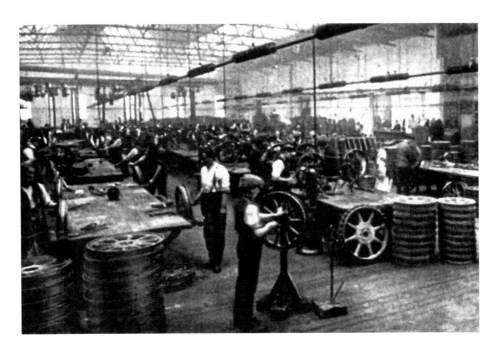

GKN Sankey

Above: Joseph Sankey bought Hadley Castle Works in 1910 and utilised the buildings of the former tramcar works. Sankey's works specialised in motor vehicle wheels and bodies, and expanded with the burgeoning motor industry.

Below: Between the wars, additional products included chassis frames, office furniture and washing machines, and by the 1960s the works had become Europe's biggest manufacturer of motor wheels, with the workforce rising to over 6,000. However, with the loss of contracts, the company's fortunes declined. A drastic reduction of the workforce and restructuring over the last thirty years have created a very different plant at Hadley. (IGMT)

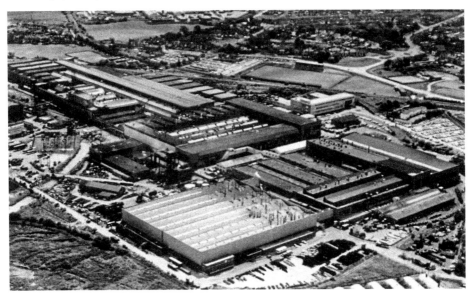

Blockley's Brickworks
Above: B. P. Blockley opened the Ragfield Tileries in New Hadley in 1898, specialising in red and blue bricks. As Blockley's Ltd, the works later expanded into adjacent areas, including this site of the former ironworks of John Wilkinson, where further supplies of clay were quarried.

Below: By the 1960s the company produced 20 million facing bricks a year. Part of the Michelmersh Brick Holding Group since 1997, the works has expanded further, and is now approached off Sommerfield Road at Trench Lock. (IGMT)

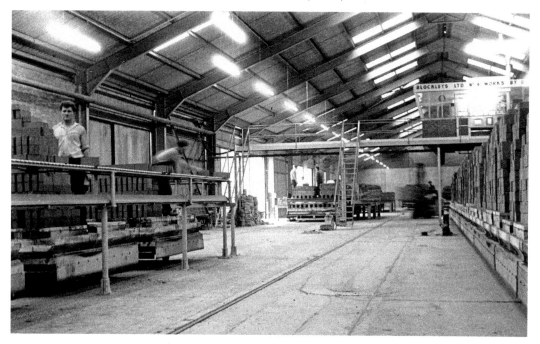

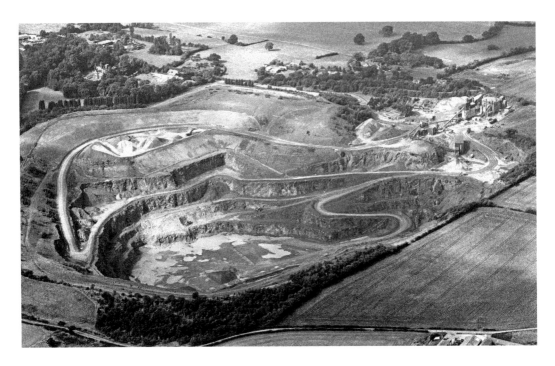

Leaton Quarry
Above: In 1820 Thomas Telford had noted the quality of road-building material in the area to the west of Wellington, and basalt and granite were quarried around Leaton and Overley during the nineteenth century. Extraction continued on a small scale, but new plant was introduced in the 1960s and larger scale quarrying began at Leaton – the extent of which can be seen in this recent aerial view.

Below: Breedon Aggregates now extracts up to 750,000 tons annually at Leaton and produces crushed rock and asphalt for road surfacing and ready-mixed concrete. Access to the site is now off the B5061 (the old A5).

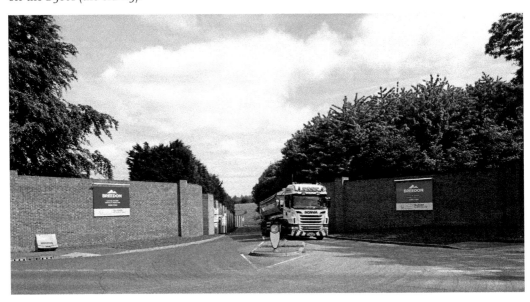

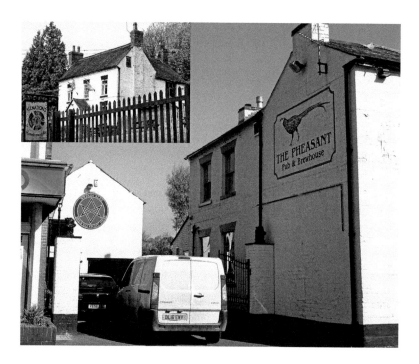

Breweries and Teddy Bears

Above: With only one short break, the All Nations public house in Coalport Road, Madeley, (inset) has brewed its own beer since 1832. Shires Brewery, the current owners, was established in 2009 and produces a range of seven regular beers. In 2014, the Ironbridge Brewery, which had been established seven years earlier on the Wharfage at Ironbridge, moved to Market Street, Wellington, where it reopened the Pheasant Inn and set up its Wrekin Brewing Co. micro-brewery in the refurbished outbuilding – opposite the site of the old Wrekin Brewery!

Below: Merrythought Ltd, founded by W. G. Holmes and G. H. Laxton in 1930, took over the former Dale End foundry, Ironbridge, to manufacture soft toys. Today, it is the last remaining factory making teddy bears in Britain, and includes this shop outlet.

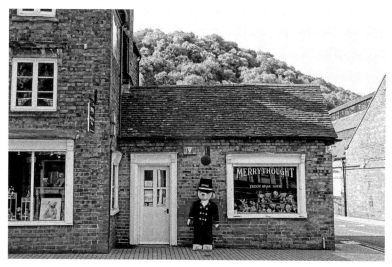

Newspapers and Tourism
Above: The earliest county newspapers, based in Shrewsbury, date from the late eighteenth century, but smaller towns, including Wellington, started their own local papers from the 1850s onwards. With the closure of the *Wellington Journal* in 1964, the *Shropshire Star*, based at Ketley, became the area's leading newspaper.

Below: Those visiting Blists Hill Victorian Town (one of the ten sites of the Ironbridge Gorge Museum Trust, now fifty years old) – or the Wrekin, the various local English Heritage and National Trust properties, the Severn Valley Railway at Bridgnorth and the RAF Museum at Cosford – are all following in the footsteps of earlier tourists to the area.

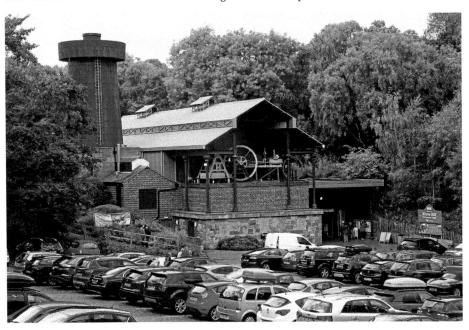

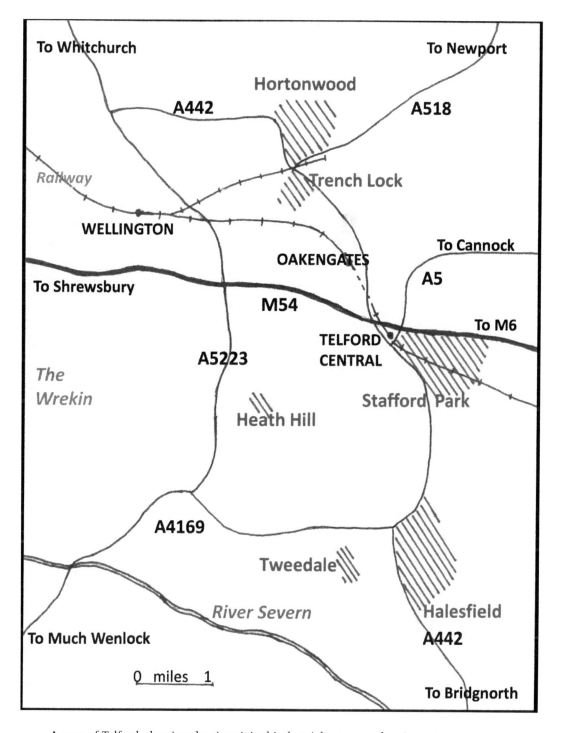

A map of Telford, showing the six original industrial estates and main routes.

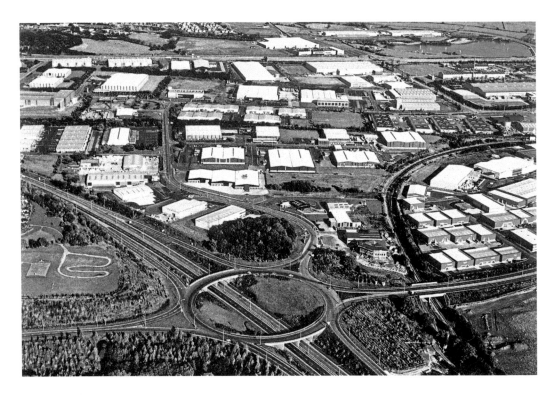

Stafford Park
Above: A bird's-eye view over Stafford Park industrial estate, east of Telford town centre, looking north-east.

Below: This traditional Chinese-style building is at the front of the headquarters of Entanet, a company founded by a Taiwanese entrepreneur, whose products evolved from computer components to wholesale internet services, but which is now under new ownership.

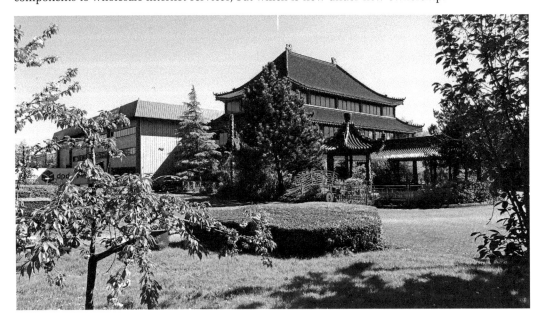

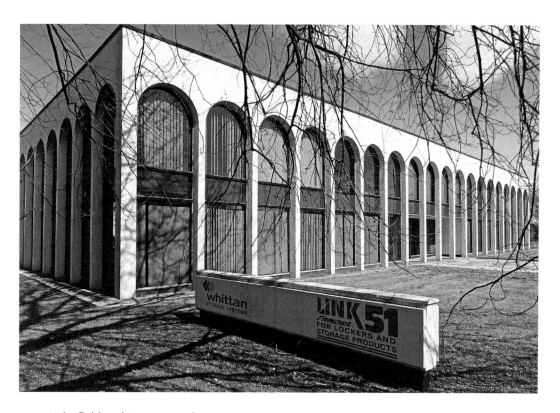

Halesfield and Hortonwood
Above: The impressive frontage of Link 51 on the Halesfield industrial estate in south Telford. The company manufactures a wide range of steel storage systems.

Below: The Denso factory on the edge of the Hortonwood industrial estate in north Telford carries out a wide variety of manufacturing to produce plastic mouldings, aluminium pressings, heat exchangers and pump and hose components.

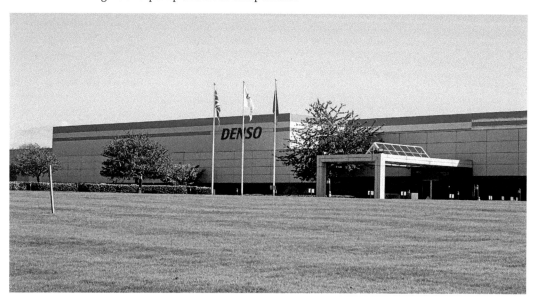

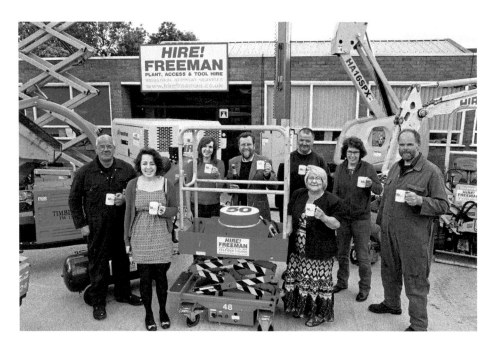

Local Enterprise
Maintaining the East Shropshire tradition of enterprise, two local examples of flourishing local businesses are Freemans of Telford and Apley Farm Shop.

Above: Freemans of Telford was established in 1961 and has been operating from its Halesfield base since 1967. Shown here with Managing Director John Freeman and staff, it is Telford's oldest independently owned plant hire business.

Below: Apley Farm Shop at Norton, an outlet for produce from the Apley estate and other local sources, was opened in 2011. It is managed by the Hamilton family, who are the owners of the estate.

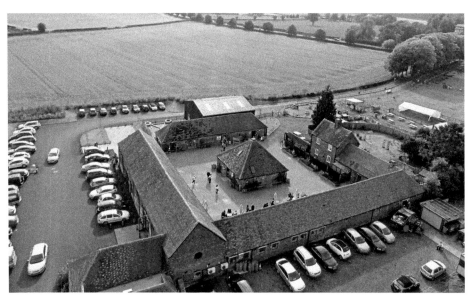